D0424989

WRITERS
and their
CATS

WRITERS
and their
CATS

By Alison Nastasi

CHRONICLE BOOKS

SAN FRANCISCO

Text copyright © 2018 by Alison Nastasi.
All rights reserved. No part of this book may be reproduced
in any form without written permission from the publisher.

Page 110 constitutes a continuation of the copyright page.

Library of Congress Cataloging-in-Publication Data
available.

ISBN: 978-1-4521-6457-1

Manufactured in China.

Design by Kristen Hewitt
Cover image by Steve Schapiro

10 9 8 7 6 5 4 3

Chronicle books and gifts are available at special quantity
discounts to corporations, professional associations,
literacy programs, and other organizations. For details
and discount information, please contact our premiums
department at corporatesales@chroniclebooks.com or at
1-800-759-0190.

Chronicle Books LLC
680 Second Street
San Francisco, California 94107
www.chroniclebooks.com

DEDICATION

To Lynx and Luna, for all the love, laughter, and light.

—Alison

CONTENTS

INTRODUCTION ... 8

Alice Walker ... 12

Allen Ginsberg ... 15

Angela Carter .. 16

Ann M. Martin .. 19

Anuja Chauhan .. 20

Berit Ellingsen .. 23

Beverly Cleary ... 24

Bing Xin ... 27

Carlos Monsiváis ... 28

Charles Bukowski ... 31

Chester Himes .. 32

Colette .. 35

Doris Lessing .. 36

Edith Sitwell .. 39

Elinor Glyn .. 40

Elizabeth Bishop ... 43

Ernest Hemingway ... 44

Gillian Flynn .. 47

Gloria Steinem ... 48

Haruki Murakami .. 51

Helen Gurley Brown ... 52

Hunter S. Thompson ... 55

Iris Murdoch ... 56

Jirō Osaragi ... 59

Jorge Luis Borges .. 60

Judy Blume ... 63

Julio Cortázar .. 64

Kazim Ali .. 67

Lilian Jackson Braun ... 68

Louise Erdrich ... 71

Lydia Davis .. 72

Margaret Mitchell .. 75

Mark Twain ... 76

Marlon James ... 79

Neil Gaiman .. 80

Patricia Highsmith ... 83

Preeti Shenoy .. 84

Ray Bradbury ... 87

Raymond Chandler ... 88

Sarah Jones .. 91

Stephen King ... 92

Sylvia Plath ... 95

Truman Capote .. 96

Ursula K. Le Guin .. 99

Zelda Fitzgerald ... 100

BIBLIOGRAPHY ... 102

CREDITS .. 110

ACKNOWLEDGMENTS .. 112

INTRODUCTION

"I wish I could write as mysterious as a cat," Edgar Allan Poe once wrote. The grandfather of gothic fiction, whose tortoiseshell muse Catarina was said to drape herself over Poe's shoulders while he worked at his desk, is just one of countless writers drawn to the cat's sphinx-like enigma. While we no longer worship our feline companions with the same devotion as the ancient Egyptian cat cults that raised decorated temples in their honor, the almighty cat continues to capture our hearts and imaginations. This innate fascination with animals of the feline persuasion seems to be most intense amongst creative circles—as with the literati, who typically share similar meditative and solitary traits. It would be a treacherous offense for the pampered cat to betray its voluptuous nature with bursts of canine-like activity, thus making bookish, writerly types the perfect companions for the fickle feline. The self-indulgent cat is loath to be bothered with more than lounging on piles of manuscripts, keeping a laptop warm, and playing resident librarian. In the writer, the cat finds a kindred spirit who is equally attuned to the subtle, unspoken nuances of life. "Cats are the natural companions of intellectuals," French veterinarian Dr. Fernand Méry wrote in his 1966 book *The Life, History, and Magic of the Cat*. "They are silent watchers of dreams, inspiration, and patient research."

Inescapably, writers are our eternal observers. They watch us and take note. They're avid keepers of humanity and unable to suppress this urge to document. Their lives are often characterized as bohemian and carefree, yet stereotypes about reclusive, brooding authors abound. There may be a scientific reason for the writer's melancholic reputation. Kay Redfield Jamison, author of *Touched with Fire: Manic-Depressive Illness and the Artistic Temperament* and a professor of psychiatry at Johns Hopkins University, has extensively studied the correlation between mood disorders and the artist's disposition. Jamison has stated that

writers are ten to twenty times more likely to suffer from bipolar disorder and depressive illnesses. "The cognitive style of manic-depression overlaps with the creative temperament," Jamison said, as reported by the *New York Times* in 1994. "When we think of creative writers, we think of boldness, sensitivity, restlessness, discontent; this is the manic-depressive temperament." As British poet Lord Byron put it. "We of the craft are all crazy. Some are affected by gaiety, others by melancholy, but all are more or less touched." Based on what we now know about the link between cat ownership and the reduction of stress, anxiety, and risk of heart disease, perhaps cat-loving writers throughout the ages were simply responding to an overwhelming biological call for feline solace from the burden of being society's storytellers.

Take one 2008 study, for example. Researchers looked at over four thousand adults between the ages of thirty and seventy-five (around half owned cats or used to) and noted that keeping cats as pets reduced the likelihood of stroke or heart attack by more than a third. Dr. Adnan Qureshi, a neurologist affiliated with the University of Minnesota, led the study and told *The Telegraph*, "The logical explanation may be that cat ownership relieves stress and anxiety and subsequently reduces the risk of heart disease." Qureshi also suggested that petting your cat (or preferred critter) can reduce stress-related hormones in the blood, thereby lowering blood pressure and reducing a person's heart rate.

Cats can be beneficial for our physical health, but also play a pivotal role in providing companionship and social support. We live in the digital age, constantly connected to online social networks, so many writers sequester themselves away to become immersed in their work and get lost in the depths of fantasy and human emotion. It might sound like a lonely life, but being an unplugged wordsmith doesn't have to be isolating. The cat's quiet presence is ideal for those

long stretches with a pen (or computer), as well as the scattered moments when writers need a gentle, purring nudge back to reality.

A study conducted by a Facebook research team in 2016 explored another organic connection between social interaction, cats, and literary types. Their results confirm a widely held belief—cat people love books. The study's findings—taken from aggregate, de-identified data, based on a sample of about 160,000 people in the United States who shared photos of their pets on the social media website—concluded that cat people "disproportionately like books." Cat lovers also "seem to express a wider variety of feelings on the site," particularly positive emotions like happiness and love. This helps dismantle the stereotype that all cat lovers, including writers, are unhappy loners. Perhaps those social media over-sharers are just would-be authors at heart.

Of course, the "feelings" described in the Facebook findings are not all upbeat and might reflect some of the negative associations commonly held with regard to bibliophiles and cats. Aloof, selfish, and temperamental could easily describe some of the world's most famous authors as well as your average tabby. If our imperfections make us human, then writers might have an advantage. "I love [cats]," Dorothy Gardner declares in Lucy Maud Montgomery's 1915 novel *Anne of the Island*, the third book in her beloved Anne of Green Gables series. "They are so nice and selfish. Dogs are too good and unselfish. They make me feel uncomfortable. But cats are gloriously human." It should come as no surprise that Montgomery was a felinophile.

The symbiotic relationship between cats and people—literary people, in particular—stems from "certain key stimuli strongly reminiscent of special properties of our own species," according to zoologist Desmond Morris's 1967 book *The Naked Ape*. Morris believes that we tend to see our favorite animals as "caricatures" of ourselves. For the writer, the cat represents traits most appealing to the creative personality—qualities like mystery, cleverness, fearlessness, unpredictability, and sensuality. The draw between writers and cats speaks to an inherent desire to seek compatible characteristics. This affirms the powerful subconscious

connection both seem to share and may explain the overwhelming presence of cats as symbols in literature.

Despite the centuries elapsed since cats were idolized by ancient cultures and believed to be totems of mythological gods and goddesses, the cat continues to be an esoteric character, guardian spirit, psychological symbol, and mirror to an otherworldly consciousness—particularly in literature. In Poe's 1843 short story "The Black Cat," the drunken, violent narrator is haunted by a mysterious feline doppelgänger that becomes an avenger for his crimes and a nagging reminder of his guilt. Hemingway's 1925 short story "Cat in the Rain" uses "poor kitty" as a way to convey the lonely wife's vulnerability—and, some critics say, her desire to have a child. The real and fantastical cats of Haruki Murakami's novels share a mystical connection to the universe and bring the subconscious longings of his characters to life on the page. French Symbolist poet Charles Baudelaire wrote of the cat's ability to transcend our earthly plane when he said that cats "seem to fall into a sleep of endless dreams" in "Les Chats" ("The Cats"), from his famed 1857 poetry collection *Les Fleurs du mal* (*The Flowers of Evil*). The concept of dreamy, divine felines might be a writer's wishful thinking, hoping to absorb some of the cat's fabled arcane wisdom and supernatural charms. But for many authors the cat simply reflects the true essence of the writer's inner world. French artist, film-maker, and *Les Enfants Terribles* author Jean Cocteau described this in a lyrical musing. "I love cats because I enjoy my home; and little by little, they become its visible soul."

ALICE WALKER

Alice Walker, activist and Pulitzer Prize–winning author of *The Color Purple*, spoke about one of her beloved cats in a 2007 interview in the Buddhist magazine *Lion's Roar*. "My cat lived a very rough life before she arrived in my home. She has one tooth that's broken and another that's kind of long on the other side. She's snaggletoothed," Walker shared. "A stranger might look at her and say, 'Oh, she has imperfect teeth.' But I look at her and see the absolute perfection—the charming perfection—of her imperfection. It gives me so much information about the kind of life she has had, and the kind of soul she has probably fashioned." Walker, whose novels examine racism and patriarchal culture, wrote about her sometimes difficult relationship with cats as an author who travels frequently in *Anything We Love Can Be Saved: A Writer's Activism*. Her former kitty Willis was named after the Willis Avenue Bridge in New York City, where she was rescued. A special cat came into Walker's life following her divorce. "I named this cat Tuscaloosa, which means 'Black Warrior' in Choctaw," she writes. "As is clear from his name, I felt extremely vulnerable, suddenly all alone in the big city, and very much in need of protection.... We lived in a tiny three-room, second-story flat in Park Slope, Brooklyn.... Often, as I worked at my desk, which overlooked the street, Tuscaloosa sat at my feet. More often I wrote propped-up in bed; he snoozed, placid and warm, by my knees." Walker later met her cat Frida at a shelter, "a two-year-old long-haired calico with big yellow eyes and one orange leg.... I named her Frida, after Frida Kahlo. I could only hope she'd one day exhibit some of Kahlo's character. That despite her horrendous kittenhood she would, like Kahlo, develop into a being of courage, passion, and poise.... When it is bedtime I pick her up, cuddle her, whisper what a sweet creature she is, how beautiful and wonderful, how lucky I am to have her in my life, and that I will love her always."

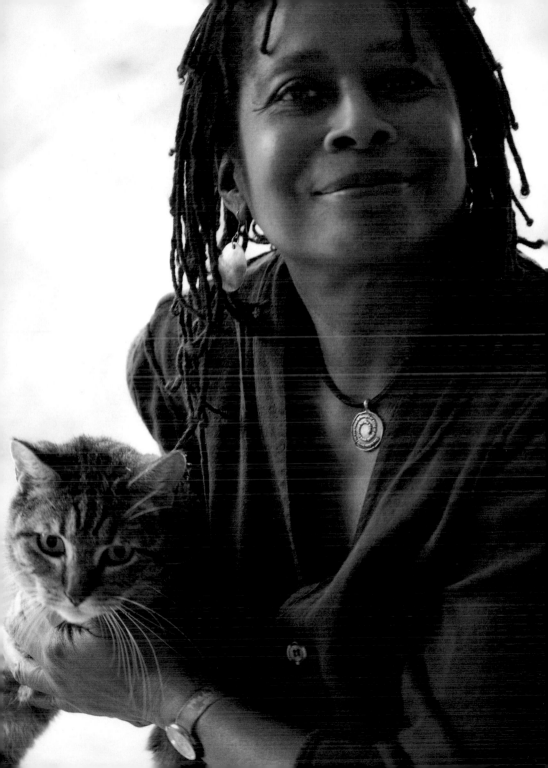

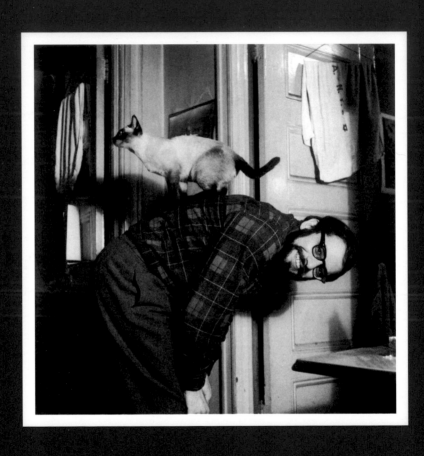

ALLEN GINSBERG

"A cat by the way sits on my shoulder as I write this," Beat Generation icon Allen Ginsberg wrote to friend and *On the Road* author Jack Kerouac in a 1954 letter. At the time, Ginsberg was living in a Nob Hill apartment in San Francisco—the same one where, during a peyote trip, he experienced a vision of Moloch, the Old Testament god, in his view of the Sir Francis Drake Hotel. The incident inspired his famous poem "Howl," which signaled the start of the Beat movement due to the high-profile obscenity trial that occurred following its publication. It's no surprise that cats loved to keep Ginsberg close since he was an anti-war demonstrator, Buddhist, and poet of peace.

ANGELA CARTER

English author Angela Carter, known for her dark feminist stories, always told people that she wrote her first novel when she was only six years old. *Bill and Tom Go to Pussy Market* was "full of social realism: cats going about their daily business." As a child, her favorite cat was named Charlie (a naughty kitty who liked to use her mother's shoes as a litter box). She adopted a white cat with "lavender ears" and "bracken-colored eyes" with her first husband, Paul Carter. After winning the Somerset Maugham Award in 1969 for her novel *Several Perceptions*, Carter used the proceeds to travel to Japan following her estrangement from Paul. During her two-year hiatus in Tokyo, she owned a tricolored black, white, and orange cat to stave off loneliness. At one point in her life, Carter also owned birds named Adelaide and Chubbeleigh. She allowed them to fly freely around her sitting room while cats Cocker and Ponce watched longingly from the garden of her London home. "I get on well with cats because some of my ancestors were witches," she wrote in 1974. "Whenever we feel at home, we secure some cats." Cats featured prominently in Carter's magical realist, picaresque tales throughout her too-short lifetime. Her subversive retelling of famous fairy tales in *The Bloody Chamber* includes a bawdy version of "Puss-in-Boots." *Comic and Curious Cats* and *Sea-Cat and Dragon King*, her two children's books, boast feline protagonists. Carter also channeled her artistic spirit through pencil and crayon drawings of cats on postcards she shared with friends.

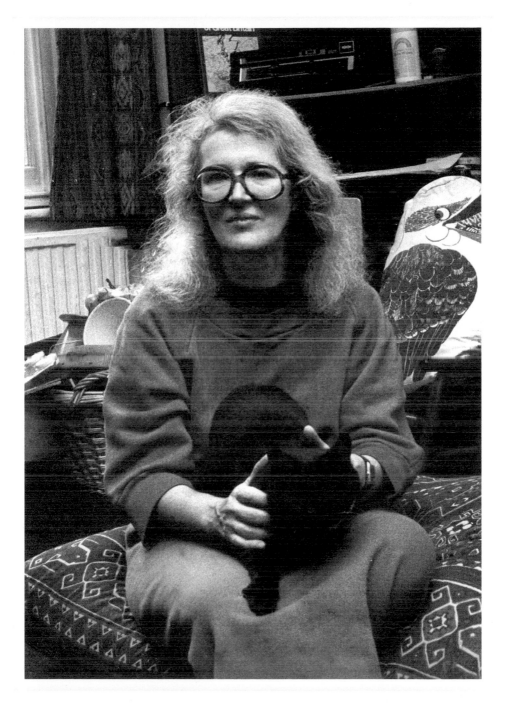

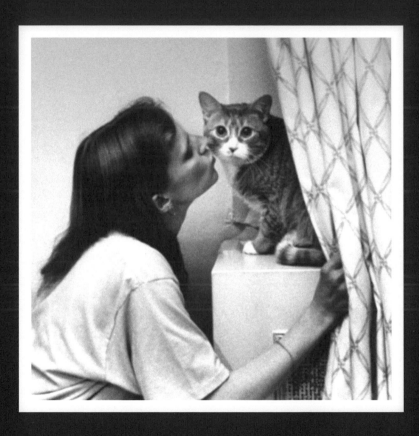

ANN M. MARTIN

Nineties kids know author Ann M. Martin as the creator of the popular Baby-Sitters Club series, which was published between 1986 and 2000. Many of the characters and situations Martin's teen protagonists faced were inspired by real people and Martin's own childhood memories. *Mallory and the Ghost Cat* features one of several fictional felines in Martin's universe, and Kristy, founder of the Baby-Sitters Club, had a pet cat named Boo-Boo. Martin currently resides in upstate New York's Hudson Valley where she lives with her cats, Gussie, Pippin, and Simon. She spends much of her free time fostering kittens for the ASPCA. In a 2016 interview for the website Vulture Martin said, "Taking care of them is like my version of babysitting."

ANUJA CHAUHAN

Anuja Chauhan, one of India's most popular genre fiction authors, started her career in advertising for companies like Pepsi. She has since made her woman-centric novels the focus of her career, including fan favorite *The Zoya Factor*. According to newspaper *The Hindu*, Chauhan's daily routine starts with the many animals that inhabit her home outside Bangalore. "In addition to the two dogs, we also have two cats, some guinea pigs, toads, and many birds that nest under every lampshade in our verandah," she shared. "So I potter around the garden for a while, catching up with the wildlife." Chauhan's feline friends have been known to make occasional appearances on her Instagram page (@anuja.chauhan), stealing her audience's attention away from her dogs.

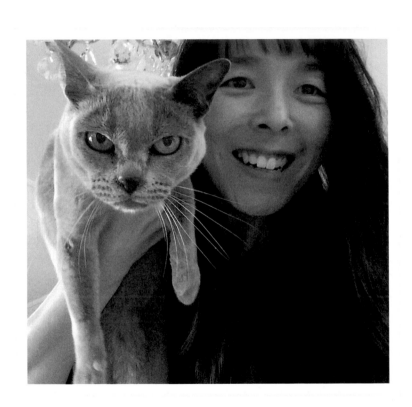

BERIT ELLINGSEN

Berit Ellingsen's debut novel *Not Dark Yet* is an introspective, restrained, tense work with humanist concerns, but the Korean-Norwegian writer isn't always as serious as her novel, thanks to her cheerful blue Burmese cat, Dotty (pictured). "She follows me around the house, sleeps in my lap for hours, and demands to be picked up (when she feels ignored) and held," Ellingsen told me. The Pushcart Prize– and British Science Fiction Award–nominated author seems to have a supernatural connection with Dotty, who meows in response to questions. Dotty shares such a strong attachment to Ellingsen that she sleeps in a cat bed on her desk while she writes. "If I'm too slow to pick her up and hug her when she wakes up, she starts pawing on my shoulder," Ellingsen said. "All my T-shirts over a certain age have holes in them on the shoulder Dotty kneads. Once I lift Dotty up she wants to lounge across my shoulder, but it's a little too heavy to type like that, so when I'm working Dotty has to go back to her cat bed." Although Dotty is affectionate with her human, she dislikes other cats and even fought the neighbor's two feline residents in their own home, earning Dotty the hilarious nickname "Darth" Dotty. "Most of the time I call Dotty 'the world's cuddliest cat.'"

BEVERLY CLEARY

The popular cat meme "If it fits I sits" is kitty speak for, "I'm going to sit on this, because I'm a cat—and I can." It's also a cry for attention, which Newbery Medal–winning children's author Beverly Cleary knows all too well. Cat-loving Cleary has owned several pet pussycats over the decades, including one who was said to beg for attention while sitting on top of her typewriter keys. Cleary's beloved 1973 book *Socks* is about the misadventures of a tabby cat with white paws who feels abandoned by his family after a baby is born. Cleary's stories were often inspired by her own life, and she wrote about serious real-life issues—including the loss of a pet. In *Ramona Forever,* the family cat Picky-Picky passes away. Cleary shows how the sisters tenderly handle his funeral and take care with each other's feelings in the aftermath.

BING XIN

With a writing career that spanned more than seven decades, Chinese writer
Bing Xin (birth name Xie Wanying) published a wide variety of imaginative
works, including poems, novels, and essays, contributing to her reputation as
one of the country's most important early modern female writers. Her work fea-
tures lyrical and sentimental observations about childhood, nature, and society.
Several photos of the author feature a fluffy cat posed by her side, guarding her
manuscripts—a companion in Bing Xin's search for truth through her thought-
ful prose.

CARLOS MONSIVÁIS

Mexican journalist and activist Carlos Monsiváis was one of the leading cultural critics and intellectuals of his time. Monsiváis, who demonstrated a passionate concern for Mexican social and political issues, was frequently photographed and filmed in his Mexico City apartment while one of his many cats posed for the camera on top of his messy desk. In keeping with his reputation as an eccentric writer, Monsiváis gave his cats unusual names: Pío Nonoalco, Carmelita Romero, Evasiva, Nana Nina Ricci, Chocorrol, Posmoderna, Fetiche de peluche, Fray Gatolomé de las bardas, Monja desmatecada, Ansia de militancia, Miau Tse Tung, Miss oginia (who Monsiváis saved from being euthanized), Miss antropía, Caso omiso, Zulema Maraima, Voto de castidad, Catzinger, Peligro para México, and Copelas o maullas. Mito Genial was one of his favorite cats. The name translates to "Brilliant Myth" and is said to cheekily reference something a finance minister said about inflation in the 1990s. Kitty and human shared such a powerful connection that the cat passed away two days before the writer in 2010. Monsiváis was a founding member and generous contributor to a foundation for homeless cats called Gatos Olvidados (Forgotten Cats).

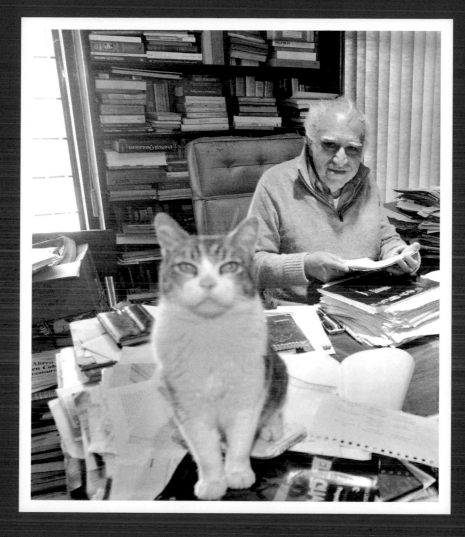

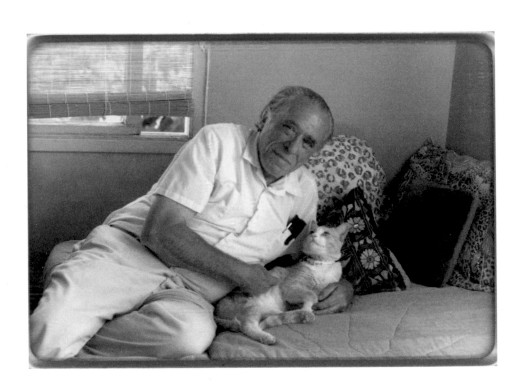

CHARLES BUKOWSKI

"I don't like love as a command, as a search," *Factotum* author Charles Bukowski wrote to friend Carl Weissner in a letter. "It must come to you, like a hungry cat at the door." If Bukowski loved anything, it was his cats. The poet and novelist, who wrote using a booze-soaked alter ego named Henry Chinaski, kept up a tough exterior, but Bukowski had a soft spot for the soulful creatures he viewed as his teachers—something he notes in one cat-inspired poem, "My Cats." Bukowski's musings on his feline brethren range from sentimental to impolite, like the amusing poem "Looking at the Cat's Balls," in which the author does exactly that. Bukowski's personal cattery included a white tailless cat named Manx, who is the subject of the poem "The History of a Tough Motherfucker," a one-eared tomcat with the very literary name Butch Van Gogh Artaud Bukowski, and Ting, who sat with the author at his typewriter. In a 1987 interview with actor Sean Penn, Bukowski said, "Having a bunch of cats around is good. If you're feeling bad, you just look at the cats, you'll feel better, because they know that everything is, just as it is. There's nothing to get excited about. They just know. They're saviors. The more cats you have, the longer you live. If you have a hundred cats, you'll live ten times longer than if you have ten. Someday this will be discovered, and people will have a thousand cats and live forever. It's truly ridiculous."

CHESTER HIMES

Chester Himes, considered the father of the black American crime novel, wrote stories that mirrored the real-life violence and racism happening in the world around him. "American violence is public life, it's a public way of life, it became a form, a detective story form," he once said. "So I would think that any number of black writers should go into the detective story form." One reprieve from the chaos of everyday life was Himes's cats, particularly his blue-point Siamese called Griot (pictured here). "Griot is named after the magicians in the courts of West African kings," Himes said in a 1972 interview. Griot was Himes's constant travel companion. When the *If He Hollers Let Him Go* author didn't bring Griot along during his adventures, Himes paid the price. In a 1971 interview Himes gave while in Stuttgart, Germany, he claimed he couldn't stay away from home too long since Griot would "certainly destroy [his] studio back home and chew up all [his] books." After Griot passed away, Himes kept a kitty named Deros, who the writer loved for her sweet personality.

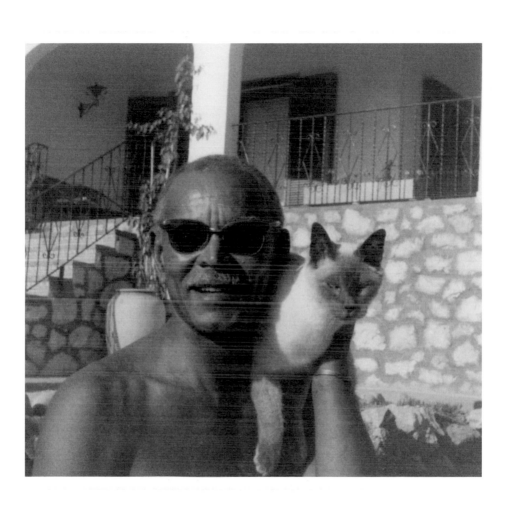

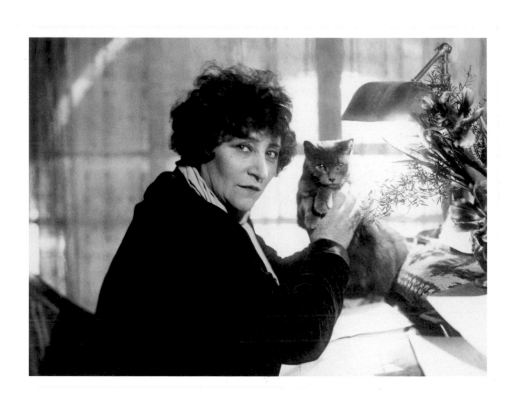

COLETTE

Like a cat, French novelist Colette (born Sidonie-Gabrielle Colette) had nine lives. She was a Nobel Prize–nominated author of sensuous and sometimes salacious novels, including the 1944 novella *Gigi*; a former music-hall performer, a figure in Parisian avant-garde intellectual and artistic circles who had affairs with women; a wife and mother; a memoirist; an essential literary voice for women; a journalist during the First World War; and a devoted cat lover. "When I enter a room where you're alone with your animals, I feel I'm being indiscreet," her second husband used to tease her. "One of these days you'll retire to a jungle." The bohemian writer saw her feline muses as mythical beings and more than just house pets. They were biographical symbols. Colette's short novel *La Chatte* details a love triangle between a man, a woman, and a cat named Saha. Her collection of one-act plays *Dialogues de Bêtes* also features felines worthy of starring roles. "There are no ordinary cats," she once said.

DORIS LESSING

Doris Lessing, the Nobel Prize–winning, Iran-born British novelist of books including *The Golden Notebook*, was raised on a farm in southern Rhodesia (now Zimbabwe), which contributed to her affection for animals, particularly cats. "What a luxury a cat is, the moments of shocking and startling pleasure in a day, the feel of the beast, the soft sleekness under your palm, the warmth when you wake on a cold night, the grace and charm even in a quite ordinary workaday puss," Lessing once said. "Cat walks across your room, and in that lonely stalk you see leopard or even panther, or it turns its head to acknowledge you and the yellow blaze of those eyes tells you what an exotic visitor you have here, in this household friend, the cat who purrs as you stroke, or rub his chin, or scratch his head." Lessing wrote about her most beloved cat named El Magnifico in a short memoir titled after the tiny beast. "The cat I communicated with best was El Magnifico," she told the *Wall Street Journal* in 2008. "He was such a clever cat. We used to have sessions when we tried to be on each other's level. He knew we were trying. When push came to shove, though, the communication was pretty limited." Other Lessing cat-centric books include 1967's *Particularly Cats* and 1993's *Particularly Cats and Rufus the Survivor*, which mention Lessing's half-Siamese darlings Gray Cat and Black Cat.

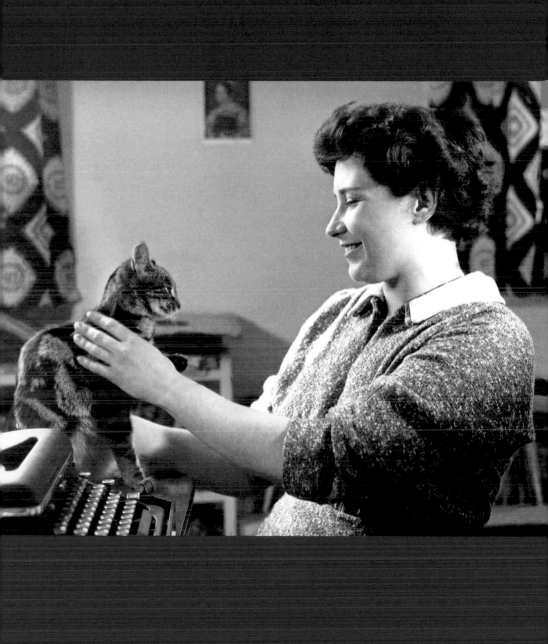

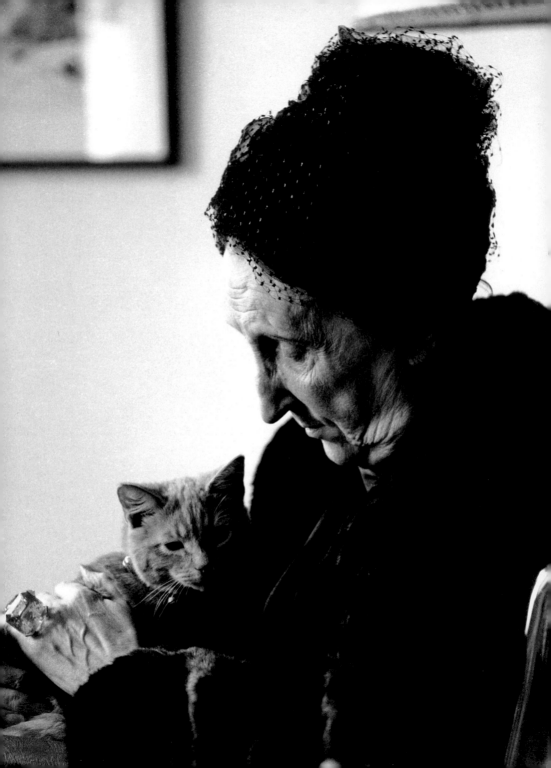

EDITH SITWELL

Edith Sitwell, the gloriously eccentric British poet who set some of her avant-garde works to music, was fond of mischievous humor, baroque fashion, and cats. Sitwell once gave a press conference from bed (wearing an elaborate hat, of course) and shared photographs of her three cats: Shadow, Leo, and Belaker. "They never say anything silly, you see, and that's something," she told reporters. In her 1965 autobiography *Taken Care Of,* Sitwell recounts a tale from her younger years when she edited the 1916 poetry anthology *Wheels* with her brothers. She used one aspiring writer's manuscript as the lining for her cat's bed. In 1962, after sitting for her portrait with Mark Gerson, a beloved photographer of writers, Sitwell wrote to the artist: "How kind of you to send me those lovely photographs of Leo. You have made him so majestic: so no matter how fine the photographs of me may be, it is Leo who should figure on the cover of [the magazine] *Books and Bookmen.*"

ELINOR GLYN

"To have 'It,' the fortunate possessor must have that strange magnetism which attracts both sexes," British novelist Elinor Glyn wrote in her 1927 novel *It*. "In the animal world 'It' demonstrates in tigers and cats—both animals being fascinating and mysterious, and quite unbiddable." Glyn, whose risqué, romantic books were aimed at a female audience, helped popularize the term "It" as another expression for someone who has that certain *je ne sais quoi*. Glyn's scandalous 1907 erotic novel *Three Weeks* was supposedly inspired by Glyn's affair with Lord Alistair Innes Ker, brother of the Duke of Roxburghe, who was sixteen years her junior. The free-spirited author's decadent lifestyle seemed to apply to her cats, too. She was often photographed with two fabulously fluffy, marmalade-colored felines Candide (shown here) and Zadig, named as a tribute to the French writer and philosopher Voltaire.

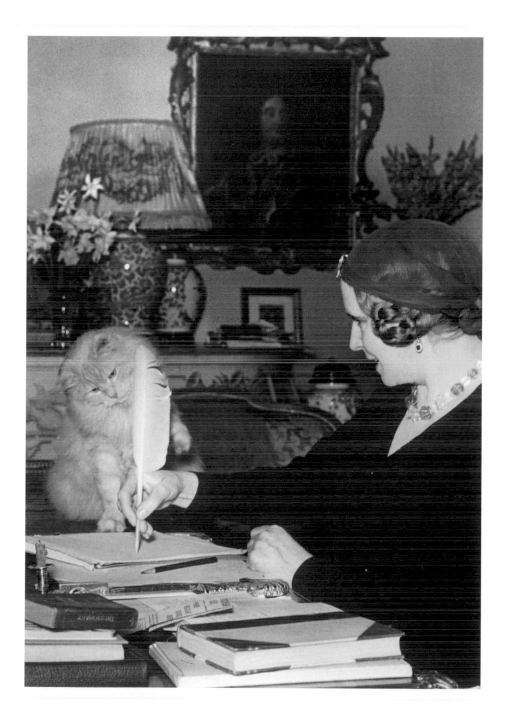

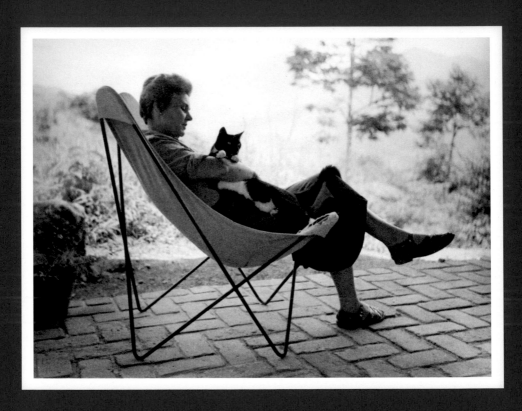

ELIZABETH BISHOP

While her colleagues were committed to a confessional writing style,
Pulitzer Prize–winning poet Elizabeth Bishop took a reserved approach to her
work, withholding the details of her private life. You can only hide so much in
photographs, however. It's clear that the poet felt at home with cats. She wrote
a lullaby for her cat, Minnow, and wrote "Electrical Storm" about her Brazilian
cat named Tobias, who was terrified of thunder and lightning. "[He] hunts all
the time, and is almost too good a butcher—arranges little rows of gall-bladders
and other portions of the mice he doesn't care for on the kitchen floor," she once
said of her beloved beast.

ERNEST HEMINGWAY

Ernest Hemingway, pictured here with his cat Cristóbal Colón, is perhaps the most famous literary cat fancier. The author of *The Old Man and the Sea* and *For Whom the Bell Tolls* owned dozens of cats at any given time. "One cat just leads to another," he wrote to his first wife, Hadley Mowrer, in 1943. "The place is so damned big it doesn't really seem as though there were many cats until you see them all moving like a mass migration at feeding time." Hemingway's cats were always treated to the best and even had their own guest bedroom in the writer's Cuban home. Most of his moggies, or as he liked to call them, "purr factories" and "love sponges," had free run of the tropical abode. Yes, "Papa" Hemingway was an unrivalled cat dad. In the foreword for Carlene Fredericka Brennen's *Hemingway's Cats*, Hemingway's niece, Hilary Hemingway, writes of her famous uncle:

> The image most people have of Ernest Hemingway is that of a macho hunter and fisherman.... There is no question that when Papa was hiking along winding rivers to take a fish on fly, or watching his prey in the African bush, he was always working to better his understanding of animals. He studied their natural habitat, analyzed their migration and feeding habits, watched the physical changes over their lifespan and, like John Audubon, Hemingway often killed the animals he studied. He examined them in life, and in death, and his writing always included that mystical bond between the hunter and the hunted.

The Hemingway cat clan lives on at the Ernest Hemingway Home and Museum in Key West, Florida. There, you will find between forty and fifty polydactyl (six-toed) cats, all named after famous people. The story goes that Hemingway was given a white six-toed cat named Snow White by a ship's captain. The cats who currently live on the museum grounds are Snow White's descendants.

"A cat has absolute emotional honesty: human beings, for one reason or another, may hide their feelings, but a cat does not," Hemingway once said of his many feline friends.

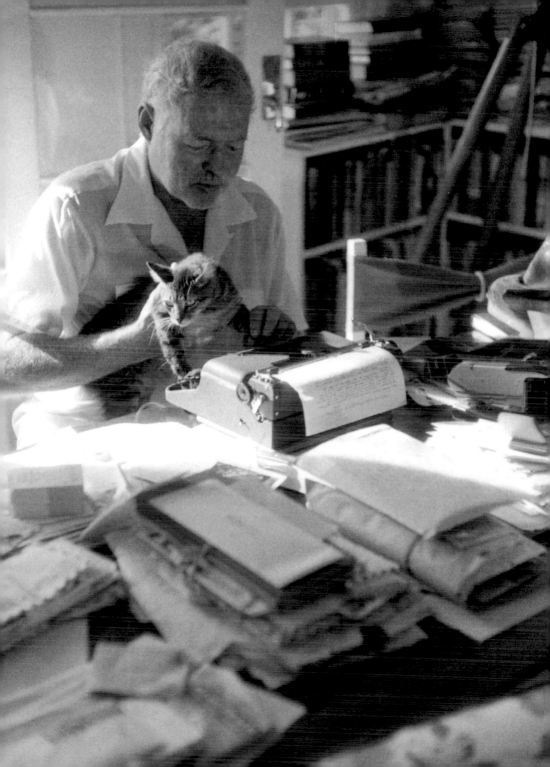

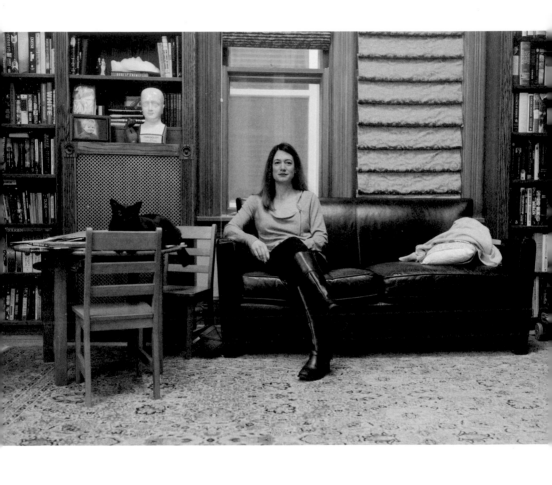

GILLIAN FLYNN

With a background in journalism and a childhood filled with books and horror movies (*Psycho* on repeat), Gillian Flynn was destined to become an author of novels that explore society's dark undercurrent. Her international best-seller *Gone Girl* became a hit film directed by David Fincher. Flynn wrote the award-winning screenplay and earned a spot on the short list of authors who successfully translated their books for the big screen. It seems fitting that Flynn, who has written about riveting female villains, serial killers, and deadly Satanic cults, keeps a black cat as her feline familiar, but she eschews the spooky stereotypes. Roy (pictured) is one of four black cats Flynn has called her pet since she was a child. "I have been a big believer that black cats are the best: affectionate, laid-back, and sweet," she told me. "Roy is a cat-dog. He trots to the door when we come home. He lolls on our laps the second we sit down. You can hear his purr coming for you from three rooms away." And if you're wondering who crafted the most tense parts of Flynn's gritty psychological thrillers, it was definitely Flynn's sharp-clawed writing partner: "Roy has 'helped' me with my last two books and all my screenplays. He prefers to sit on the keyboard, so he can type things like GY*T^&$$^R^&h&&G!!! Now that I work on a tread desk he sits by me, watching. He's a very sweet sentinel."

GLORIA STEINEM

Internationally renowned journalist Gloria Steinem is the cofounder of *Ms.* magazine. She was a leader of the women's liberation movement in the 1960s and '70s and remains an essential figure in the feminist movement, paving the way for women to find equality in every aspect of their lives. Steinem's stance that women should do whatever they damn well please is an attitude her cats can relate to. The feline friends who have shared a home with Steinem include Crazy Alice (pictured). "She grew into a mysterious and self-willed companion," Steinem told me. The activist has a special fondness for her late gray Persian, Magritte. "She became the cat of my life.... Magritte was my teacher when it comes to a strong will and self-authority.... When large numbers of women came to sit in a circle for a meeting, she sat on the arm of a big chair for hours, and became an alert participant. Even people who didn't like cats were knocked out by Magritte." Steinem's current companion is a long-haired, gray-and-white Egyptian Mau that was rescued from the streets of Cairo where she lost her back left paw in an accident. Her name is Fendi, not to be confused with the Italian fashion house. The nickname is most likely short for "Effendi" or "Efendim," which Steinem explained is a Greek, Persian, and Arabic term of respect for someone in a high position. Being a three-footed cat hasn't stopped Fendi from taking ownership of her new home. "When I have meetings, she sits for hours on the arm of the chair where Magritte once did, looking at each woman as she speaks, very much part of the circle," Steinem shares. "She climbs onto my lap at my desk, or onto my desk, or on the couch when I'm reading.... She absolutely will not eat anything that doesn't have a lot of gravy. She is very elegant; a living work of art." Steinem believes cats are "a writer's most logical and agreeable companion."

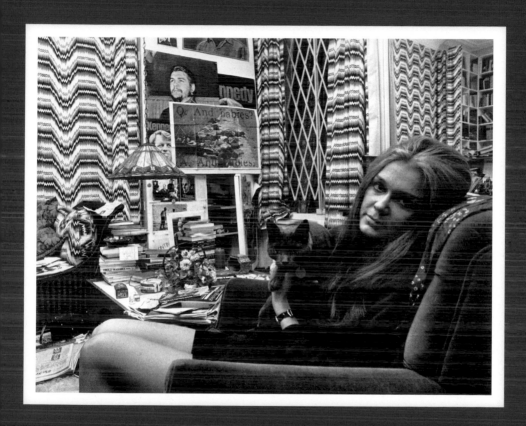

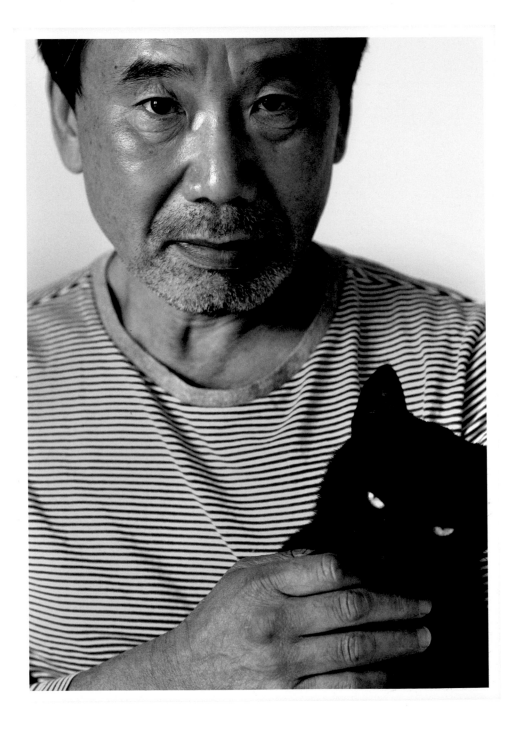

HARUKI MURAKAMI

In an essay titled "Choju Neko no Himitsu" ("The Secret of an Old Cat"), acclaimed Japanese novelist Haruki Murakami tells a story about how he asked an executive at publishing company Kodansha Ltd. to take care of his cat while he traveled. In exchange for the favor, Murakami promised he would write a novel for the company. That book turned out to be his 1987 bestseller *Norwegian Wood*, about a Tokyo college student's very different relationships with two women. It catapulted him to literary stardom. In the same essay, the author talks about writing his first book *Hear the Wind Sing*: "I still remember well the days when I was writing my first novel at night, with the cat on my lap and sipping beer. The cat apparently didn't like me writing a novel and would often play havoc with my manuscript on the desk." Murakami, widely considered one of our greatest living writers, features cats regularly in his fiction—sometimes a seemingly mundane detail, other times an enigmatic symbol or omen. His book *The Wind-Up Bird Chronicle* stars a missing cat; *Kafka on the Shore* features a character who can communicate with lost cats; and the essay "On the Death of My Cat" shares Murakami's personal stories about the many mewling muses he's shared his life with: Kirin, Butch, Sundance, Mackerel, Scotty, Calico, Peter, Black, Tobimaru, Croquette, and (fittingly) Muse. In 1974, Murakami, an avid jazz fan with an enviable vinyl collection, opened up a club in suburban Tokyo and named it Peter Cat after his pet. The venue closed in 1981. During the day, patrons came for coffee. By night, they were served food and drinks and enjoyed live jazz. Murakami often played bartender, cleaned, and acted as DJ. The space was decorated with countless cat-themed accessories and figurines.

HELEN GURLEY BROWN

"Pussycat" was Helen Gurley Brown's favorite term of endearment for friends and strangers alike—an expression that exuded warmth and familiarity. The word itself became a personal totem for the longtime editor in chief of *Cosmopolitan* magazine. Occasionally, she would even sign her name by drawing a cat. Brown wrote for the modern, single, career-minded woman. Her best-selling and often controversial books (such as *Sex and the Single Girl,* 1962) told women they could have it all: love, sex, financial independence, glamorous clothes, and zero guilt when it came to having a good time. This life of sophistication wasn't just a dream; Brown was living it. She was often photographed in her chic Park Avenue apartment with her pet chocolate-point Siamese cats named Samantha and Gregory. In the 1970s, *Cosmo*'s mascot and logo was a pink cartoon pussycat named Lovey who wore a big red bow. When Brown passed away in 2012, Lovey's image was engraved on her memorial stone.

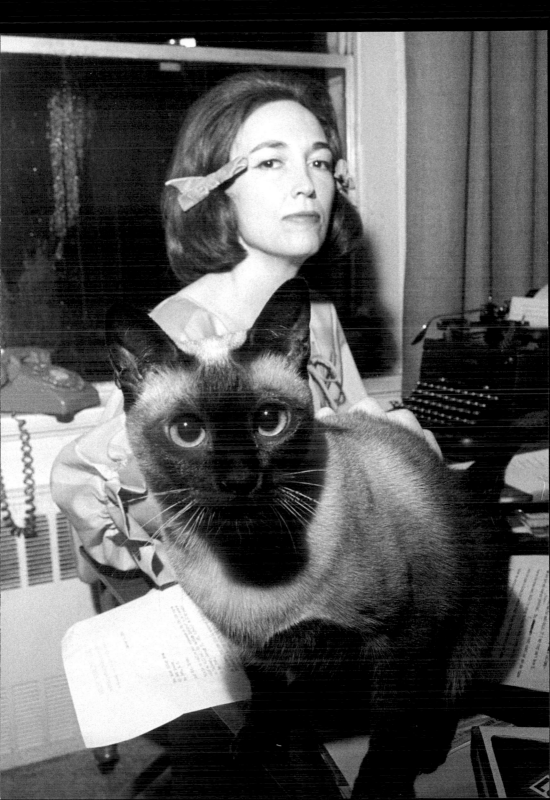

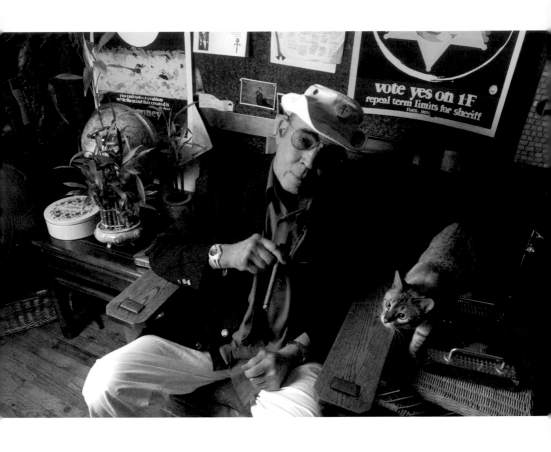

HUNTER S. THOMPSON

In 1966, gonzo journalist Hunter S. Thompson made his publishing debut with
Hell's Angels: The Strange and Terrible Saga of the Outlaw Motorcycle Gangs. The
nonfiction novel took an uncompromising look at the infamous motorcycle club.
Thompson was able to get up close and personal with the biker gang. In 1967,
Thompson took the money he earned from his book sales and purchased a two-
story log cabin on a piece of land in Colorado. Thompson named his "compound"
Owl Farm, after one of his many aliases, Sebastian Owl. There, when the *Fear
and Loathing in Las Vegas* author wasn't firing his guns during target practice,
perched by an open window in his "catbird seat" to fire off warning shots at
trespassers, or blowing up his old Jeep Wagoneer (yes, really), he was tending
to the many animals roaming his property, including peacocks, a German shep-
herd, and two Siamese cats named Caesar and Pele. Anita Bejmuk, Thompson's
widow, has said that the kitties were the writer's "babies."

IRIS MURDOCH

British novelist Martin Amis once said of Iris Murdoch, author of *Under the Net* and *The Bell*, "Her world is ignited by belief. She believes in everything: true love, veridical visions, magic, monsters, pagan spirits. She doesn't tell you how the household cat is looking, or even feeling: she tells you what it is thinking." Murdoch's writing focused on the inner lives of her characters—and it's easy to imagine the author observing the cats close to her, crafting stories in her head about their mysterious animal lives. Eventually cats appeared in her books, such as *The Nice and the Good*. As a child, Murdoch's family included several cats, like Tabby and Danny-Boy (who liked to growl at birds from the windowsill). Murdoch's father, himself a cat lover, used to wish the family felines goodnight before bed. An ongoing gag between Murdoch and her husband, the writer John Bayley, would involve each one telling the same friend, "I don't like cats, but [Iris/John] does."

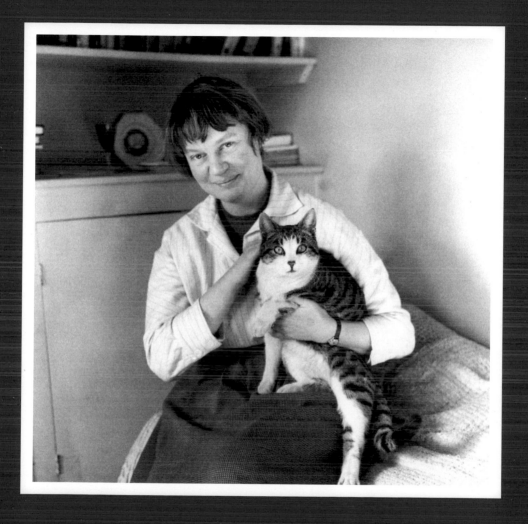

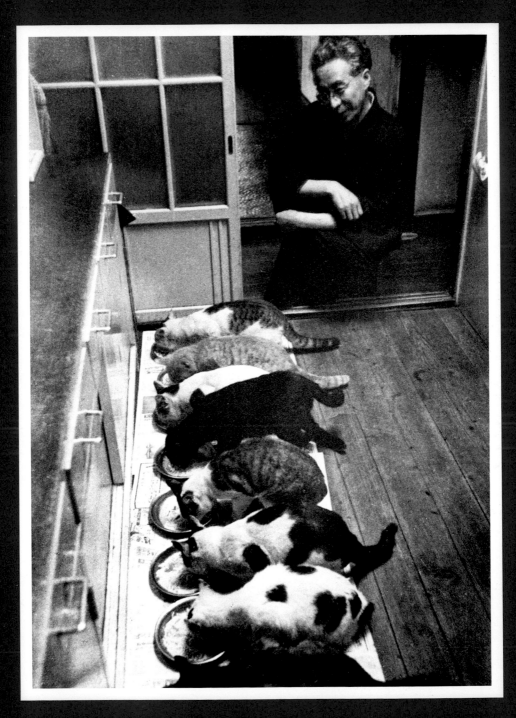

JIRŌ OSARAGI

The Osaragi Jirō Memorial Museum in Yokohama, Japan, is dedicated to the author Jirō Osaragi and features numerous cat ornaments as integral parts of its feline-themed decor. Osaragi wrote several novels connected to Yokohama, including *Muteki* (*Foghorn*) and *Gento* (*Magic Lantern*), and he lived at the Hotel New Grand for over ten years (in Room 318). It's often said that the Shōwa-period author cared for over 500 cats throughout his lifetime at his home in Kamakura, Japan, which is sometimes open to the public. Visitors can lounge on Osaragi's terrace and sip tea while picturing the hundreds of semi-feral cats that once frolicked in the gardens.

JORGE LUIS BORGES

"You belong to another time / You are lord / Of a place bounded like a dream," the Jorge Luis Borges poem "To a Cat" reads. The Argentine poet, essayist, and short-story writer who helped popularize Latin American literature shared his humble life with several cats, including a large white feline called Beppo, named after a character in a Lord Byron poem about a man who is lost at sea. Borges wrote his own poem for his companion: "The celibate white cat surveys himself / in the mirror's clear-eyed glass, / not suspecting that the whiteness facing him / and those gold eyes that he's not seen before / in ramblings through the house are his own likeness. / Who is to tell him the cat observing him / is only the mirror's way of dreaming?"

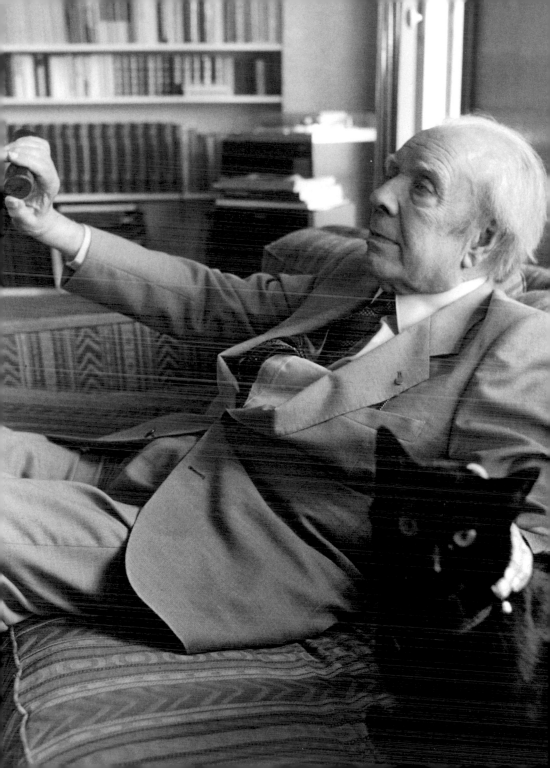

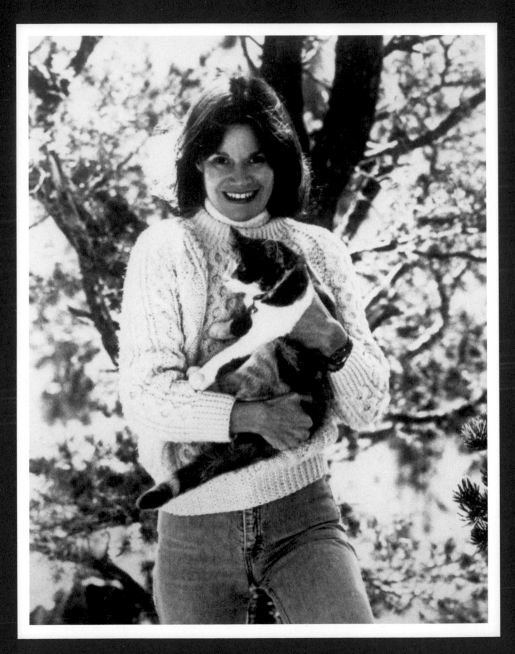

JUDY BLUME

Judy Blume, author of *Are You There God? It's Me, Margaret,* has always shared her life with animals. "We had a wonderful Calico cat who lived to be sixteen," Blume writes on her website. "Now our children have the pets and we get to visit them." Blume even called her son Larry's dog, Mookie, her "grand-dog." Judy was photographed with her neighbor's cat in 1978 (pictured). Sadly, Judy's cat Chanel had run away around that time, but the young-adult novelist, known for her frank writing style dealing with challenging subjects like teenage sexuality, sometimes includes cats in her books, like 1977's *Starring Sally J. Freedman as Herself,* which features Omar the cat.

JULIO CORTÁZAR

"He had as much confidence in his cats' opinions as in the judgments of literary critics," said poet and translator Stephen Kessler of Julio Cortázar. Kessler helped bring the experimental Argentine novelist and short-story writer's poems to English-speaking readers for the first time with the 2016 volume *Save Twilight*. In *Around the Day in Eighty Worlds*, Cortázar offered some insight into his feline fixation: "I sometimes longed for someone who, like me, had not adjusted perfectly with his age, and such a person was hard to find; but I soon discovered cats, in which I could imagine a condition like mine, and books, where I found it quite often." The book also mentions the *Rayuela* author's real-life cat Theodor W. Adorno (pictured), named after the German sociologist and philosopher.

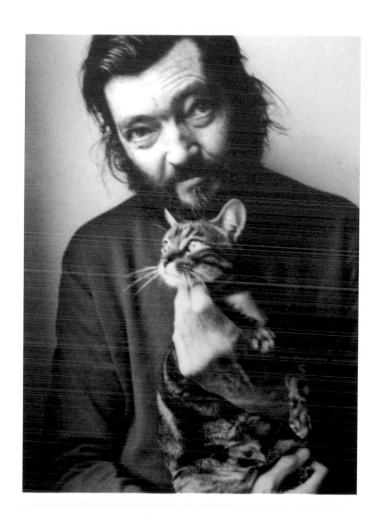

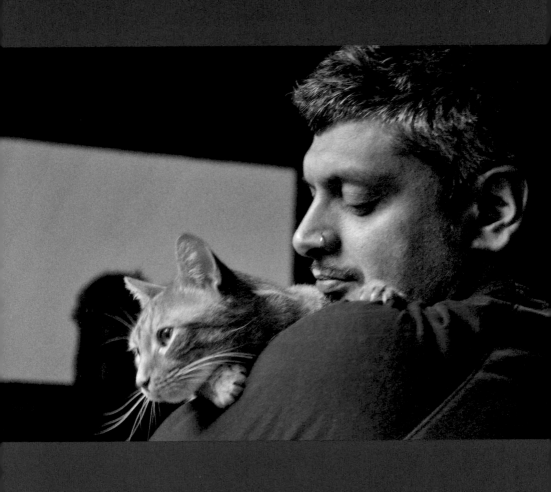

KAZIM ALI

"Cats and writers are both intuitive and solitary people," poet, editor, and prose writer Kazim Ali told me. "My cats, like me, have both extrovert and introvert aspects to their personalities. Cats and writers give each other space, but they also know when one another need love and attention." Ali, born in the U.K. to Muslim parents of Indian, Iranian, and Egyptian descent, spends long hours working on multiple projects at once. Cats have often kept the *Quinn's Passage* and *The Disappearance of Seth* author company during his marathon writing sessions. Ali's beloved late cat Genji (shown here) used to occupy the back of the writer's chair, his lap, or his forearms while he worked. The author used to place Genji in a paper or canvas grocery bag and hang it off the back of the chair to reclaim his desk and keep kitty happy. "He would hang in the bag quite comfortably for forty-five minutes or so, leaving me in peace to type," Ali said. Naturally, Ali gave his kitty a literary name:

> We called him Genji, after the legendary Shining Prince of the
> Japanese classic novel, because he always wanted to cuddle up with
> everyone. Like the Genji of the story he used to creep into bed after it
> was dark, sometimes even crawling under the covers to find me. He
> had a human-like habit of lying next to me with his head on the pillow
> and his body along my torso, his paw on my chest and one leg flung
> over my waist. After he passed, and I was grieving, a friend said that
> cats are more than human: they are our children, our roommates, our
> best friends, and our lovers all together. And that feels right.

Ali's home is now run by Genji's adopted sister Professor Minerva McGonagall (a gray-brown tabby with a white chin and paws and a very *Harry Potter* name), or Minu for short.

LILIAN JACKSON BRAUN

Lilian Jackson Braun's The Cat Who... mystery series is a delight for cat fanciers everywhere. The stories revolve around reporter Jim Qwilleran and his pair of intrepid Siamese sleuths. Koko and Yum Yum (both named after characters in Gilbert and Sullivan's *The Mikado*) assist "Qwill" in solving crimes. Braun's novels are full of fun feline details and quirks. Koko demands an expensive diet that includes lobster, while Yum Yum's crossed violet-blue eyes betray her keen ability to manipulate things with her paws. Both cats offer Qwilleran clues about the crime by tipping over important books and spinning booby traps out of yarn balls to catch the bad guys. In a 1998 interview, when asked if her own cats (pictured here) inspired her work, Braun said, "I don't believe I could write the books without my cats. Every day they do something that gives me an idea. They are very creative, and what they do starts me off on a new idea, so I am very much influenced by my two cats, Koko III and Pitti-Sing."

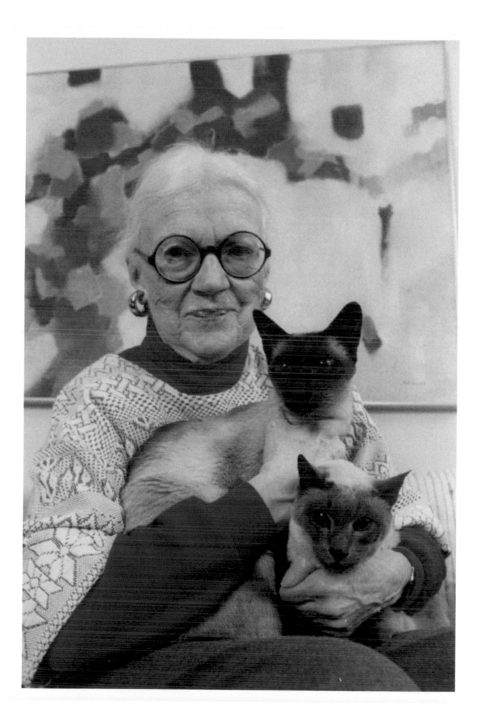

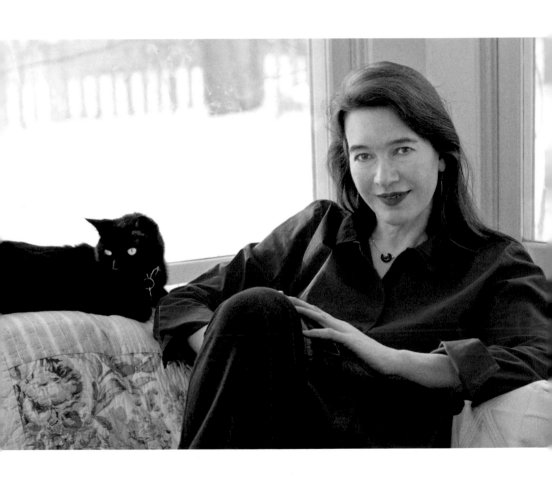

LOUISE ERDRICH

Louise Erdrich, an essential figure in post-1960 Native American literature, has penned fifteen novels, numerous short stories, poetry collections, children's books, and a memoir about the joys and struggles of motherhood called *The Blue Jay's Dance*. She describes the latter as "a book of conflict, cats, a writing life, wild places in the world, and my husband's cooking. It is a book about the vitality between mothers and infants, that passionate and artful bond into which we pour the direct expression of our being." Erdrich, who received the Library of Congress Prize in American Fiction, explores Native and non Native cultures (Ojibwe people are especially prominent in her writing), and cats have always been a presence throughout her works. *The New Yorker* published Erdrich's 2014 short story "The Big Cat," about a family of snoring women who sound like large cats when they sleep. The author currently owns an independent bookstore in Minnesota called Birchbark Books, which seems like prime real estate for a special cat in Erdrich's life.

LYDIA DAVIS

"Only [Lydia] Davis's slippery, often stoic attention to language could make fetish objects of curtain tassels, pestles, a cat, a tea bag, the entire state of Florida—and make fetishists of us all," wrote Leigh Bennett in the literary journal *The Critical Flame*. The author's cats, like Colin (pictured here), have always been friends to Davis. Interviewers often remark about the author's cats greeting them at her home. From her short story/flash fiction works "The Cats in the Prison Recreational Hall" and "The Mouse" to "Brief Incident in Short a, Long a, and Schwa," Davis shares her obsession for details—including the comings and goings of cats. In "Molly, Female Cat: History/Findings," from her collection *Can't and Won't: Stories*, Davis makes a hilarious, lengthy list that tests her reader's patience for the minutiae of her cat's life: "Cries when petted just above tail / Sometimes cries before or after urinating / Sometimes cries after nap."

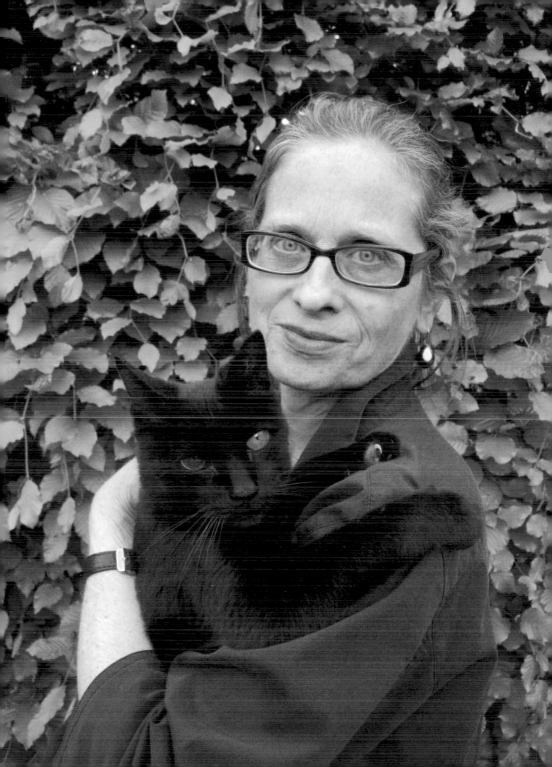

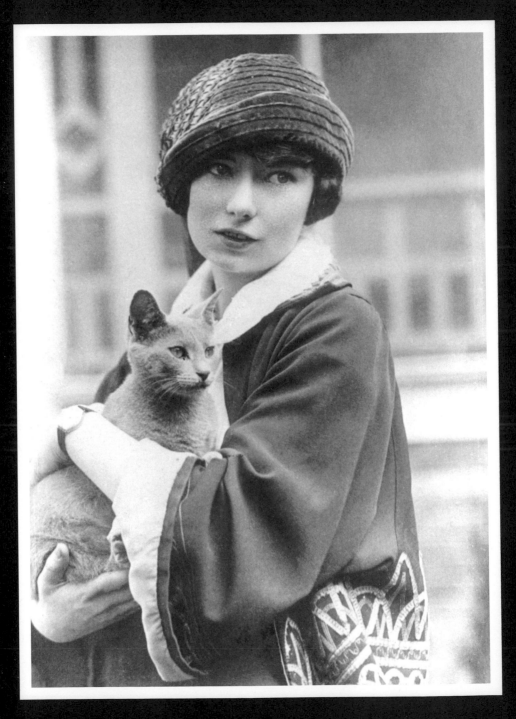

MARGARET MITCHELL

The film adaptation of *Gone with the Wind* gets all the glory, but Margaret Mitchell's popular book about a petulant Southern belle won both a National Book Award and a Pulitzer Prize. Cats and horses were Mitchell's favorite animals, but she never restricted herself to loving only felines and equines. As a young girl, her family's Atlanta household was bustling with critters, including dogs (one, a collie named Colonel after Teddy Roosevelt), ducks (Mr. and Mrs. Drake), turtles, alligators, and more. Mitchell kept cats as pets her entire life and even wrote about them in *The Atlanta Journal*, where she worked before penning her famous American Civil War–era novel.

MARK TWAIN

If anyone deserves the title of cat enthusiast, it's Mark Twain. The *Adventures of Tom Sawyer* author once wrote: "When a man loves cats, I am his friend and comrade, without further introduction." And, goodness, did Twain love cats—over thirty of them. Always the gifted raconteur, Twain's autobiography is a must-read for fans of the cranky cat collector, who at one time put an ad out in all the newspapers when his beloved black kitty Bambino went missing. Lines of fans with random cats showed up at the Twain household just to get a peek at the famous writer.

Owning cats, however, wasn't enough for Twain. He also rented them:

> Many persons would like to have the society of cats during the summer vacation in the country, but they deny themselves this pleasure because they think they must either take the cats along when they return to the city, where they would be a trouble and an incumbrance, or leave them in the country, houseless and homeless. These people have no ingenuity, no invention, no wisdom; or it would occur to them to do as I do: rent cats by the month for the summer, and return them to their good homes at the end of it.

Twain was witty as ever when it came to naming his precious pets. He claimed that their elaborate monikers were chosen to help his children practice their pronunciation. The Twain menagerie included Abner, Motley, Stray Kit, Fraulein, Lazy, Buffalo Bill, Soapy Sal, Cleveland, Satan (found on the way to church)—who was renamed Sin when Twain realized she was a girl—Famine, Pestilence, Sour Mash (said to be his favorite cat who "had many noble and engaging qualities, but at bottom she was not refined, and cared little or nothing for theology and the arts"), Appollinaris, Zoroaster, Blatherskite, Babylon, Bones, Belchazar, Genesis, Deuteronomy, Germania, Bambino, Ananda, Annanci, Socrates, Sackcloth, Ashes, Tammany, Sinbad, Danbury, and Billiards (there is a photo of Twain tucking a kitten into the corner pocket of a pool table so it might entertain itself with the billiard balls).

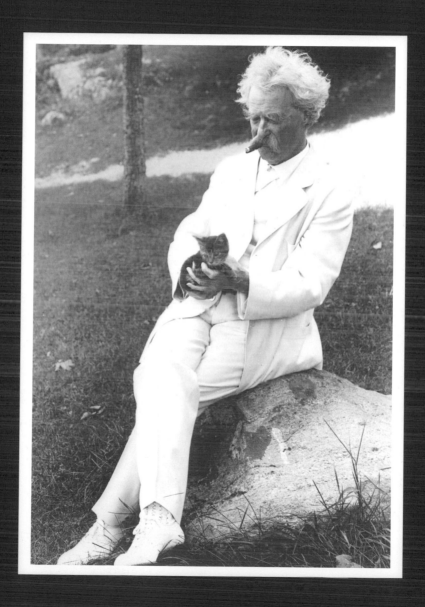

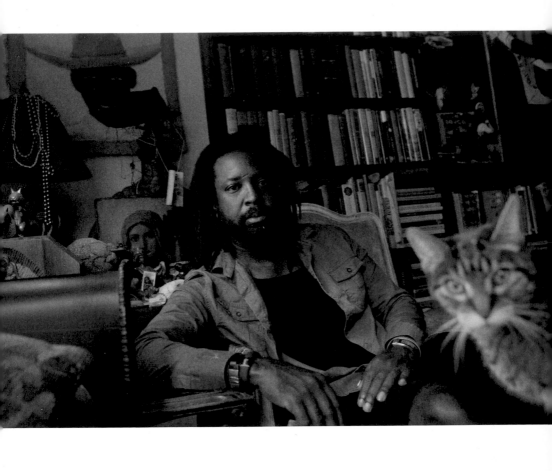

MARLON JAMES

Jamaica-born author Marlon James, whose 2015 novel *A Brief History of Seven Killings* won the Man Booker Prize, has described himself as a "write-every-day writer." James wrote *Seven Killings* "all over the cities" in Minnesota—including the Aster Café on Main Street and the Espresso Royale on Hennepin. "I have to engage with the world when I write," he told *MinnPost* in 2015. "I need the buzz of activity." Bookstore and coffee shop cats around the world love to greet and snuggle the author, but one was particularly crazy about him. James used to help care for Tom the Cat, who belonged to James's friends Kurt and Camilla Thometz in Washington Heights, New York. "Kurt also ran a bookstore, so you could say [Tom] was one of New York's legendary bookstore cats," James told me. "I think he got used to me, since he would jump in my bed and photobomb shoots." Sadly, Tom (pictured here) passed away in 2017 after "a very long and pretty epic life." The two friends shared such a strong connection that James was there during Tom's final days. "Tom had lived a long life and was getting very old, and last year I got a message from Kurt saying that Tom was on his last legs but would love to see me," James shared. "I was in New York so I went to visit. Kurt told me later that he wasn't sure what I did, but the cat rallied for two weeks."

NEIL GAIMAN

English author Neil Gaiman (*American Gods*, *Coraline*) has kept an online journal since 2001. The "cats" label will take you through countless stories about the many felines who have shared Gaiman's home—Coconut, Princess, Pod, Hermione, and Fred the Black Cat amongst them. Gaiman, whose award-winning works include graphic novels, screenplays, short fiction, and more, seemed to have a particular affection for a tiny cat named Zoe (pictured). "It's like living with a fluffy bundle of love. Fourteen years ago, she was a barn kitten in a place my daughter used to ride," Gaiman wrote in a 2010 blog entry. "About eighteen months ago I realized that she was completely blind. People go up to the attic, or sleep in the bedroom she lives in, and they love her, and she loves them back." Photographer Kyle Cassidy interviewed Gaiman about Zoe in 2010. "I used to try and write in the turret, but the only thing that would happen was that I'd pet Zoe all day," the co-creator of *The Sandman* told Cassidy. For more intimate tales of kittenly encounters, watch Christopher Salmon's adaptation of Gaiman's short story "The Price." The animated film, based on Gaiman's real-life encounter with a stray cat that wandered into his home, uses the author's humble abode as a model.

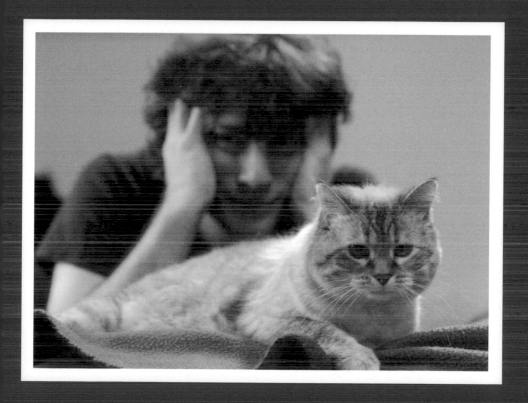

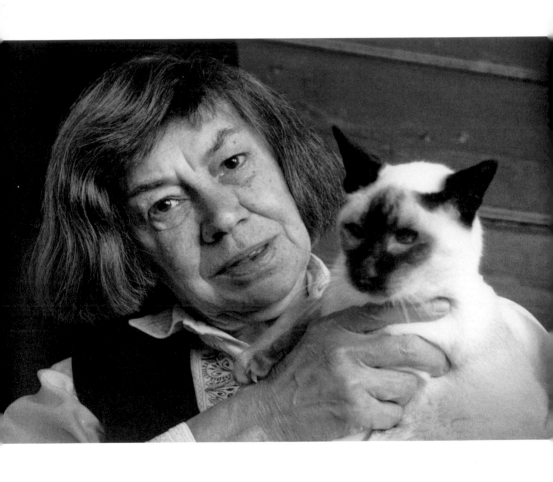

PATRICIA HIGHSMITH

Patricia Highsmith, author of *The Talented Mr. Ripley* and *Strangers on a Train*, didn't have a reputation that gave people the warm fuzzies, but her gruff personality seemed to soften around her cats. She seemed to prefer them to humans. "My imagination functions much better when I don't have to speak to people," Highsmith once said. Still, she always looked to her pet to tackle the day head-on. "When I get up in the morning, I first of all make the coffee and then I say to my cat, we're going to have a great day," the author told Naim Attallah in an interview. Highsmith shared her life with many cats, including her chocolate-point Siamese named Semyon (who loved to chase his tail), Sammy, Spider, Charlotte (who wouldn't stop crying when Highsmith passed away), and an unnamed "brindle cat" she got for her birthday. Spider was eventually given to Scottish author Muriel Spark who said: "You could tell he had been a writer's cat. He would sit by me, seriously, as I wrote, while all my other cats filtered away." Dogs never seemed to make it very far in a Highsmith novel, but cats always survived. Highsmith was also known to sketch her cats, despite spending most of her time with them curled around her typewriter. When asked what she always dreamt of having in life, Highsmith responded: "A charming two-story house, good martinis and a good dinner with French wine. . . . a wife, and books and a Siamese cat."

PREETI SHENOY

A gorgeous Doberman named Lostris dominates the social media pages of
Preeti Shenoy, the Indian novelist and artist, but the best-selling author of *Life
Is What You Make It* is still a bona fide cat magnet. "Cats always come to me and
are friendly with me. My earliest childhood memory was with a black cat that
we used to own," she told me. "When I travelled to Orissa [now Odisha], India,
I came across an interesting custom in a temple, where cats are worshipped."
Shenoy wrote about the experience on her blog (www.preetishenoy.com),
sharing a fascinating story about her trip to Kedar-Gouri Temple (also known
as the Kedareswar Temple), devoted to Lord Shiva (Kedareswar) and Goddess
Kedar-Gauri. The locals' devotion to cats, Shenoy writes, has its origin in a
folktale about a poor village family. The hungry wife drinks milk meant to be an
offering to the Goddess, but tries to hide her wrongdoing by blaming it on the cat.
Goddess Kedar-Gauri couldn't bear to see the animal punished and rescued the
cat, making it her "vaahan"—a symbolic animal elevated to divine status that
is worshipped the same as a god or goddess. This explains the large number of
feline residents at the temple, as people frequently honor the Goddess with the
gift of a kitten.

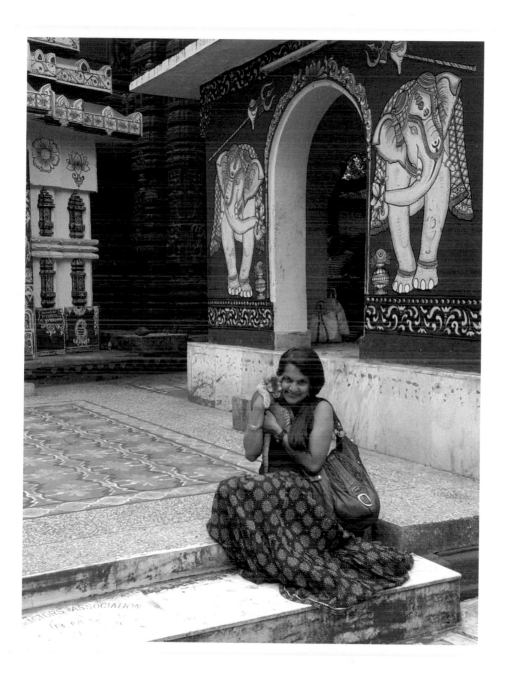

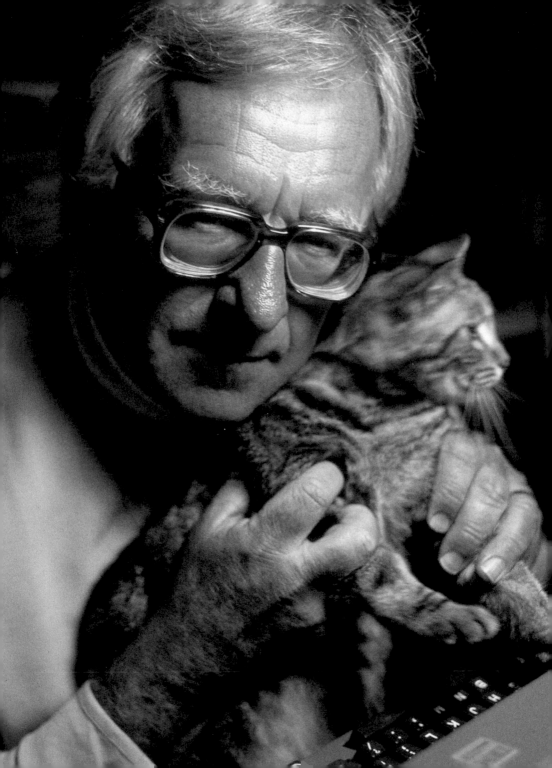

RAY BRADBURY

In the late 1950s, famous feline fanatic Ray Bradbury and his wife Marguerite (Maggie) shared their Cheviot Hills home in Los Angeles, where the couple lived for more than fifty years, with twenty-two cats. For Bradbury, cats weren't just pets. They were an integral part of his creative process. "That's the great secret of creativity. You treat ideas like cats. you make them follow you," he wrote in the 1992 book *Zen in the Art of Writing*. The Bradbury cats, including Jack, Win-Win, Dingo, and Ditzy, were mostly skittish and didn't always come out to greet company. But when the *Fahrenheit 451* author set out to write in his basement office that was lined with books, toys, and trinkets, a cat would surely follow. "I have my favorite cat, who is my paperweight, on my desk while I am writing," he once said.

RAYMOND CHANDLER

Raymond Chandler, author of *The Big Sleep* and *The Long Goodbye* and an avid epistolarian, wrote perhaps hundreds of letters to friends, colleagues, and family—and he was never short on words when it came to his cats. In 1945, Chandler introduced his cat Taki (pictured), who lived with the family for twenty years, to literary critic James Sandoe in a letter:

> The secretary, I should perhaps add, is a black Persian cat, 14 years old, and I call her that because she has been around me ever since I began to write, usually sitting on the paper I wanted to use or the copy I wanted to revise, sometimes leaping up against the typewriter and sometimes just quiet gazing out of the window from a corner of the desk, as much as to say, "The stuff you're doing's a waste of my time, bud." Her name is Taki (it was Take, but we got tired of explaining that this was a Japanese word meaning bamboo and should be pronounced in two syllables), and she has a memory like no elephant ever even tried to have. She is usually politely remote, but once in a while will get an argumentative spell and talk back for ten minutes at a time. I wish I knew what she is trying to say. . . , but I suspect it all adds up to a very sarcastic version of "You can do better." I've been a cat lover all my life (have nothing against dogs except that they need such a lot of enter-taining) and have never quite been able to understand them. Taki is a completely poised animal and always knows who likes cats, never goes near anybody that doesn't, always walks straight up to anyone, how-ever lately arrived and completely unknown to her, who really does.

A later letter to Sandoe calls Taki "positively tyrannical" and "lazy"—lovingly, of course. Chandler even wrote letters as Taki to his friends' cats. When Taki died in 1951, Chandler adopted a new cat and also named him Taki since he resem-bled the writer's former "secretary."

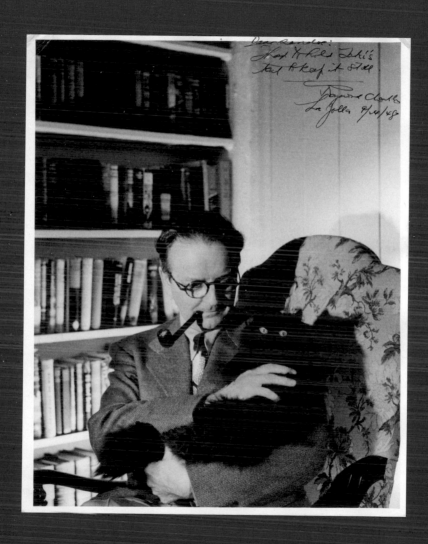

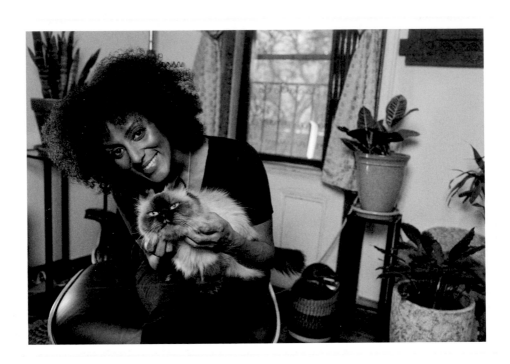

SARAH JONES

Sarah Jones is a Tony Award–winning monologist, TED speaker, creator of *The Sarah Jones Show*, slam poet who fought the Federal Communications Commission over the censorship of her poem/song "Your Revolution," and an outspoken humanitarian. Despite the demands of her one-woman shows, Jones told me that she still makes time for her fourteen-year-old cat Marley (pictured):

Marley is almost fourteen now, but he's been with me since he could fit into the palm of my hand. I grew up with cats and dogs, always rescued from shelters. But in 2003 I passed a pet store that had a litter of newborn Himalayan kittens in its window. I couldn't resist going inside, and neither could anyone else. It was an onslaught of cuteness unlike anything I'd seen— kids begging their parents, two couples fighting over one little guy like it was the Barney's warehouse sale. But out of the fray, Marley came crawling (if you could call it crawling; he was more like throwing himself forward in impossibly adorable, furry little fits) right up my arm, nestled on my shoulder, and purred in my ear. He basically got my credit card out of my wallet and paid for himself—I couldn't wait to get him home. But I also felt guilty about having bought a pet, supporting a system I didn't believe in, especially when there were so many animals in need. I tried to put it out of my mind, but the question "How can I be ok with this?" lingered for a few days, till I got an unexpected answer. When I took Marley to the vet to be sure he was healthy, they discovered he had a serious congenital heart problem (a major issue common in Himalayans because of breeding practices). Had he not come home with me or someone else soon, he might not have survived at all. So all these years later I still think of Marley as the most expensive rescue ever, and worth every purry little penny.

STEPHEN KING

Horror author and master of the macabre Stephen King has published some chilling stories about the family pet and other animals. *Cujo* is about a rabid dog who ends up terrorizing his own family. A family's dead cat comes back to life in *Pet Sematary*, except he's . . . different. That terror tale was inspired in part by real events after the King family cat Smucky was run over by a car. The late kitty was buried in a pet cemetery up a wooded path behind the King house where the author would sometimes write. The King-scripted film *Sleepwalkers* features bipedal were-cats. The 1985 film *Cat's Eye*, written by King and based on his stories "Quitters, Inc." and "The Ledge," features a mysterious cat protagonist throughout the three-chapter anthology. "The Cat from Hell" is a short story King wrote in 1977 for a magazine contest and involves an unusual cat that becomes the target of a hitman. Despite all this, cats aren't afraid to curl up for the long-term at the King residence. *The Shawshank Redemption* author has owned several pets over the years, including "a rather crazed Siamese cat" named Pear.

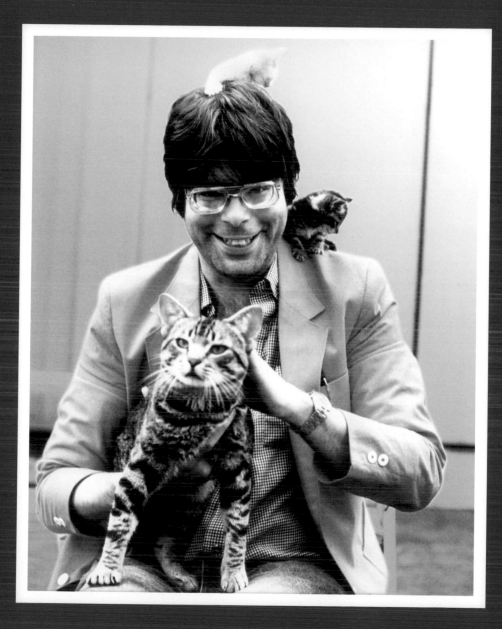

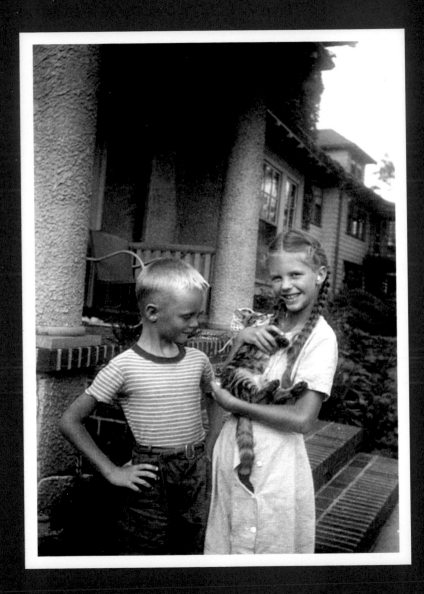

SYLVIA PLATH

Sylvia Plath's autobiographical writing and confessional poetry explored her own anguished inner world, her tumultuous relationships, and the struggles of the mid-twentieth-century woman. Plath supposedly named her childhood cat Daddy, the title of one of her most famous and anthologized poems. In 1954, when Plath studied at Harvard Summer School and lived with Nancy Hunter-Steiner in apartment 4 at 1572 Massachusetts Avenue, she adopted a cat she named Nijinsky, after the Russian ballet dancer, "because of his graceful movements." Plath's poem "Ella Mason and Her Eleven Cats" is about a ruddy-faced spinster/cat lady:

> Old Ella Mason keeps cats, eleven at last count,
> In her ramshackle house off Somerset Terrace;
> People make queries
> On seeing our neighbor's cat-haunt,
> Saying: "Something's addled in a woman who accommodates
> That many cats."

Plath also left behind a charming drawing of a "curious French cat."

TRUMAN CAPOTE

In Truman Capote's 1958 novella *Breakfast at Tiffany's*, about the life of a small-town girl turned New York café–society darling, protagonist Holly Golightly laments, "If I could find a real-life place that made me feel like Tiffany's, then I'd buy some furniture and give the cat a name." In the 1961 film adaptation starring Audrey Hepburn, the nameless kitty was played by a male marmalade tabby and famous feline thespian named Orangey. Capote also brings up cats numerous times in his 1966 true-crime novel *In Cold Blood* as a way to allude to the slyness of ex-convicts Richard "Dick" Hickock and Perry Smith.

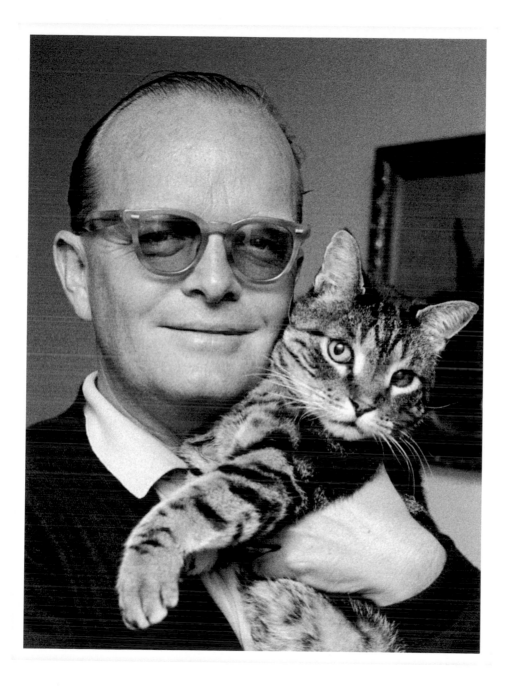

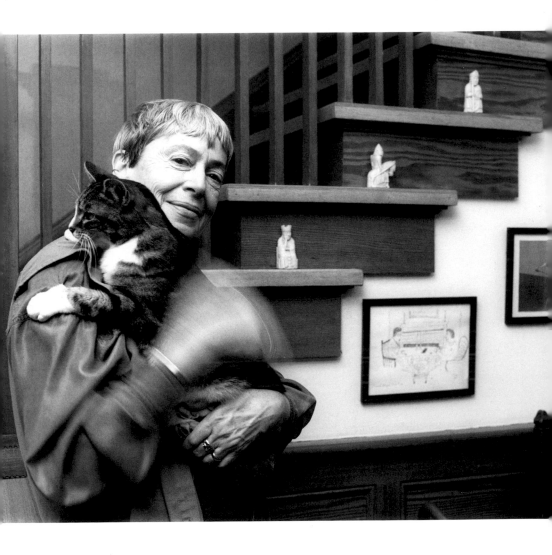

URSULA K. LE GUIN

Drawing on sociological, anthropological, and Taoist concerns, novelist, poet, and essayist Ursula K. Le Guin creates genre fiction that is inspired by the landscape and profound elemental forces. Her first trip to the Eastern Oregon desert led her to write her 1970 novel *The Tombs of Atuan*. The 1985 feminist novel *Always Coming Home* reads in part like an anthropologist's field notebook. Even Le Guin's feline companions demonstrate a strong connection to nature. Her former tabby Lorenzo, Bonzo for short (pictured), was born to a tiny cat Le Guin called Mother Courage. "She had to live feral at the old ranch, but had known better days," Le Guin told me. "The children she brought up in the wilderness were cheerful, mannerly, intelligent, resourceful, brave hunters, affectionate friends. Bonzo was one of the great cats of my life." When it was time to eat breakfast, Bonzo spared no mercy. "I was still asleep [and] he would walk delicately across my face, and when I opened my eyes there were his big golden eyes two inches away. Best alarm clock ever." Le Guin's current feline friend is Pardner, nicknamed Pard. The author even wrote his autobiography, *My Life So Far*. "He sleeps a lot on the writing desk next to my computer," she shared. "If I get very emotionally involved in what I'm writing (letter or fiction), it makes him uneasy and he comes over and sits on the mouse and purrs. Try writing with a cat sitting on your mouse." When asked why she is fond of cats, Le Guin said, "Because they are beautiful and funny and self-respecting and mysterious." The author planted tongue firmly in cheek when asked why there seems to be a special relationship between writers and cats: "Maybe because writers don't want to have to stop writing and walk the dog?"

ZELDA FITZGERALD

Zelda Fitzgerald, the "First American Flapper," socialite, novelist, and wife of author F. Scott Fitzgerald, had recently published her 1932 novel *Save Me the Waltz* when her photo was taken to promote the book. She had a cat cradled in her arms. Much of what we know about the Fitzgerald cats is through thoughtful, intimate letters Zelda wrote to her husband during his travels while they lived in a Greek Revival mansion named Ellerslie near Wilmington, Delaware, and a house the couple purchased in Montgomery, Alabama, at 819 Felder Avenue. Chat the cat, a white Persian they called Chopin, and "a little cat pretty and poised and wild with as many antennae as a swamp lily" are just a few of the kitties who called Zelda mama. She often shared her poetic and humorous observations about the feline visitors: "The cat is the most beautiful fellow. He broods over ancient Egypt on the hearth and looks at us all contemptuously." In a letter to writer, photographer, and friend Carl Van Vechten, Zelda again captured the essence of catitude at its finest: "One of [the cats] is splotchy but mostly white with whiskers although he is sick now, so his name is Ezra Pound. The other is named Bouillabaisse or Muddy Water or Jerry. He doesn't answer to any of them so it doesn't matter."

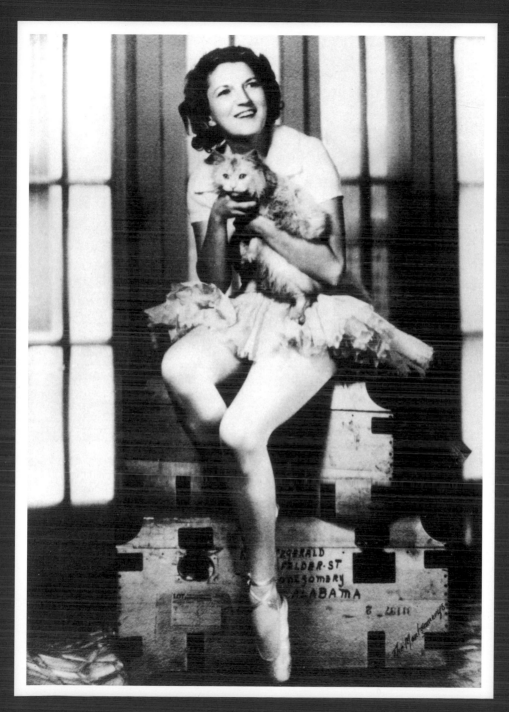

BIBLIOGRAPHY

Adamic, Lada, Moira Burke, Amaç Herdağdelen, and Dirk Neumann. "Cat People, Dog People." Facebook Research. August 7, 2016. https://research.fb.com/cat-people-dog-people.

"A Woman of Her Time." L. M. Montgomery Research Centre. Accessed July 15, 2017. http://www.lmmrc.ca/exhibit/of_her_time.html.

Badillo, Juan Manuel. "¿Dónde están los gatos de Carlos Monsiváis?" *El Economista*. June 21, 2010. http://eleconomista.com.mx/entretenimiento/2010/06/21/donde-estan-gatos-carlos-monsivais-0.

Banner, Geonni. "The Murakami/Cat Connection." Shelter from the Storm. November 30, 2014. http://atpeacewithpink.blogspot.com/2014/11/normal-0-false-false-false-en-us-x-none_85.html.

Bennett, Leigh. "50 Shades of Lydia Davis." The Critical Flame. September 7, 2015. http://criticalflame.org/50-shades-of-lydia-davis.

Blume, Judy. "Questions for Judy." JudyBlume.com. Accessed July 15, 2017. http://www.judyblume.com/about/questions/family.php.

Bonhams. Accessed July 17, 2017. https://www.bonhams.com/auctions/17860/lot/20.

Bradbury, Ray. AZQuotes.com. Accessed July 16, 2017. http://www.azquotes.com/quote/33885.

Bradbury, Ray. *Zen in the Art of Writing: Releasing the Creative Genius Within You*. New York: Bantam, 1992. https://www.amazon.com/Zen-Art-Writing-Releasing-Creative/dp/0553296345.

Brennen, Carlene. *Hemingway's Cats: An Illustrated Biography*. Sarasota, FL: Pineapple Press, 2006. http://www.pineapplepress.com/shop/hemingways-cats-an-illustrated-biography/.

Brewer, Robert Lee. "A Poet's Brain: 'It's Alive!'" Writer's Digest. December 7, 2015. http://www.writersdigest.com/whats-new/a-poets-brain-its-alive.

Bryer, Jackson R., and Cathy W. Barks. *Dear Scott, Dearest Zelda: The Love Letters of F. Scott and Zelda Fitzgerald*. New York: Macmillan, 2003. https://books.google .com/books?isbn=0312282338.

Bukowski, Charles. *On Cats*. New York: HarperCollins, 2015. https://books.google .com/books?isbn=0062396013.

Bukowski, Charles. *Selected Letters Volume 2: 1965–1970*. New York: Random House, 2012. https://books.google.com/books?isbn=1448114500.

Butscher, Edward. *Sylvia Plath: Method and Madness*. Tucson, AZ: Schaffner Press, 2003. https://books.google.com/books?isbn=0971059829.

Cassidy, Kyle. "Love Your Four Legged Beasties." Kyle Cassidy. January 21, 2010. http://kylecassidy.livejournal.com/576999.html.

"Charles Baudelaire's Fleurs du mal / Flowers of Evil." Fleursdumal.org. Accessed July 31, 2017. http://fleursdumal.org/poem/155.

Clapp, Susannah. *A Card from Angela Carter*. New York: Bloomsbury USA, 2012. https://books.google.com/books?isbn=1408828421.

Cline, Sally. *Zelda Fitzgerald: The Tragic, Meticulously Researched Biography of the Jazz Age's High Priestess*. New York: Skyhorse, 2012. https://books.google.com/ books?isbn=161145963X.

Cocteau, Jean. AZQuotes.com. Wind and Fly LTD. Accessed July 31, 2017. http://www.azquotes.com/quote/59450.

Colette, Sidonie-Gabrielle. AZQuotes.com. Wind and Fly LTD. Accessed July 31, 2017. http://www.azquotes.com/quote/356619.

Conradi, Peter J. *Iris Murdoch: A Life*. New York: W. W. Norton & Company, 2001. https://books.google.com/books?isbn=0393048756.

Cortázar, Julio. GoodReads. Accessed July 15, 2017. https://www.goodreads.com/quotes/129830-i-sometimes-longed-for-someone-who-like-me-had-not.

Crossen, Cynthia. "Just Asking . . . Doris Lessing." *The Wall Street Journal*. October 18, 2008. https://www.wsj.com/articles/SB122427970148245879.

Davis, Anita Price. *The Margaret Mitchell Encyclopedia*. Jefferson, NC: McFarland, 2013. https://books.google.com/books?isbn=0786492457.

Dawidziak, Mark. *Mark Twain for Cat Lovers: True and Imaginary Adventures with Feline Friends*. Lanham, MD: Rowman & Littlefield, 2016. https://books.google.com/books?isbn=1493027093.

Devlin, Kate. "Owning a Cat 'Cuts Stroke Risk By Third.'" *The Telegraph*. March 19, 2008. http://www.telegraph.co.uk/news/uknews/1582144/Owning-a-cat-cuts-stroke-risk-by-third.html.

Doris Lessing. *Particularly Cats*. DorisLessing.org. Accessed July 14, 2017. http://www.dorislessing.org/particularlycats.html.

Elinor Glyn. National Portrait Gallery. Accessed July 14, 2017. http://www.npg.org.uk/collections/search/person/mp01798/elinor-glyn.

Elinor Glyn with Her Cats Candide and Zadig. National Portrait Gallery. Accessed July 14, 2017. http://www.npg.org.uk/collections/search/portrait/mw165235/Elinor-Glyn-with-her-cats-Candide-and-Zadig.

Erdrich, Louise. *The Blue Jay's Dance: A Birth Year*. New York: Harper Collins, 1996. https://books.google.com/books?isbn=0060927011.

Espeland, Pamela. "Marlon James Talks about Adverbs, His Writing Habits, and Books That Matter to Him." *MinnPost*. November 4, 2015 https://www.minnpost .com/artscape/2015/11marlon-james-talks-about-adverbs-his-writing-habits-and-books-matter-him.

Fabre, Michel, and Robert E. Skinner. *Conversations with Chester Himes*. Jackson: University Press of Mississippi, 1995. https://books.google.com/ books?isbn=0878058184.

Gaiman, Neil. "Zoe." Neil Gaiman: Journal. January 21, 2010. http://journal .neilgaiman.com/2010/01/zoe.html.

Ginsberg, Allen, and Bill Morgan. *The Letters of Allen Ginsberg*. Boston: Da Capo Press, 2008. https://books.google.com/books?isbn=0786726016.

Gordon, Edmund. *The Invention of Angela Carter: A Biography*. New York: Oxford University Press, 2017. https://books.google.com/books?isbn=0190626844.

Greene, Richard. *Edith Sitwell: Avant Garde Poet, English Genius*. London: Little, Brown Book Group, 2011. https://books.google.com/books?isbn=1405511079.

Grimes, William. "Exploring the Links Between Depression, Writers, and Suicide." New York Times. November 14, 1994. http://www.nytimes.com/1994/11/14/books/ exploring-the-links-between-depression-writers-and-suicide.html.

Hendrix, Grady. "The Great Stephen King Re-read: Pet Sematary." Tor.com. January 24, 2013. http://www.tor.com/2013/01/24/the-great-stephen-king-re-read-pet-sematary.

Highsmith, Patricia. AZQuotes.com. Wind and Fly LTD. Accessed August 01, 2017. http://www.azquotes.com/quote/132011.

Hiney, Tom, and Frank MacShane. *The Raymond Chandler Papers: Selected Letters and Nonfiction 1909–1959.* New York: Grove Press, 2012. https://books.google.com/books?isbn=0802194338.

Jordison, Sam. "Booker Club: The Sea, The Sea." *The Guardian.* February 11, 2009. https://www.theguardian.com/books/booksblog/2009/feb/10/iris-murdoch-sea-booker.

"Jorge Luis Borges: Traveling Not Only in Space, But in Time." UPI. October 14, 1984. http://www.upi.com/Archives/1984/10/14 Jorge-Luis-Borges-Traveling-not-only-in-space-but-in-time/9670466574400.

Joseph, Raveena. "Anuja Chauhan on Her Latest Book: The House That BJ Built." *The Hindu.* August 16, 2017. http://www.thehindu.com/features/metroplus/interview-of-bestselling-author-anuja-chauhan/article7499462.ece.

Levy, Paul. "Obituary: Dame Iris Murdoch." *The Independent.* February 10, 1999. http://www.independent.co.uk/arts-entertainment/obituary-dame-iris-murdoch-1069841.html.

Lidz, Gogo. "Soon You Too Can Tour Hunter S. Thompson's House." *Newsweek.* July 15, 2015. http://www.newsweek.com/2015/08/14/hunter-s-thompson-gonzo-owl-farm-colorado-woody-creek-fear-and-loathing-dr-353780.html.

MacShane, Frank. *Selected Letters of Raymond Chandler.* New York: Columbia University Press, 1981. https://books.google.com/books?isbn=0231050801.

Mancini, Mark. "12 Charming Tidbits about Beverly Cleary." Mental Floss. April 12, 2016. http://mentalfloss.com-article/56708/12-charming-tidbits-about-beverly-cleary.

Margolies, Edward, and Michel Fabre. *The Several Lives of Chester Himes.* Jackson: University Press of Mississippi, 1997. https://books.google.com/books?isbn=1617035084.

Martin, Ann M. Scholastic. Accessed July 3, 2017. http://www.scholastic.com/
annmartin/about.

Millier, Brett C. *Elizabeth Bishop: Life and the Memory of It*. Berkeley and Los
Angeles: University of California Press, 1992. https://books.google.com/
books?isbn=0520917197.

Montgomery, Lucy Maud. *Anne of the Island*. New York: Grosset & Dunlap, 1915.
https://books.google.com/books?id=NXnhAAAAMAAJ.

Morris, Desmond. *The Naked Ape: A Zoologist's Study of the Human Animal*. New
York: Delta, 1999. https://www.amazon.com/Naked-Ape-Zoologists-Study-Animal/
dp/0385334303.

Mualem, Shlomy. *Borges and Plato: A Game with Shifting Mirrors*. Madrid:
Iberoamericana-Vervuert, 2012.

"Murakami the Cat Lover." Wednesday Afternoon Picnic. May 28, 2011. http://
wednesdayafternoonpicnic.blogspot.com/2011/05/murakami-cat-lover.html.

"National Cat Day with Mark Twain." University of California Press Blog.
Accessed July 15, 2017.
http://www.ucpress.edu/blog/19562/national-cat-day-with-mark-twain.

Neelis, Koty. "17 Inspiring Quotes about Cats That Will Make You Lose Faith in
Dogs." Thought Catalog. October 15, 2013. https://thoughtcatalog.com/koty-neelis/
2013/10/17-inspiring-quotes-about-cats-that-will-make-you-lose-faith-in-dogs.

Jirō Osaragi. *QK Kamakura* magazine. Accessed July 15, 2017. http://qk-kamakura
.com/people/jiro-osaragi.

"Patricia Highsmith." Naim Attallah Online. October 1, 2014. https://quartetbooks
.wordpress.com/2014/01/10/patricia-highsmith/.

Penn, Sean. "Tough Guys Write Poetry." Bukowski.net (republished from *Interview* magazine, September 1987). https://bukowski.net/poems/int2.php.

Popova, Maria. Brainpickings Explore. "To a Cat" by Jorge Luis Borges. August 24, 2013. http://explore.brainpickings.org/post/59193926816/to-a-cat-by-jorge-luis-borges-august-24.

Publishers Weekly. Photo. August 5, 2016. http://publishersweekly.tumblr.com/post/148507813391/he-had-as-much-confidence-in-his-cats-opinions.

Rosman, Katherine. "Who Owns Helen Gurley Brown's Legacy?" *New York Times*. August 22, 2015. https://www.nytimes.com/2015/08/23/fashion/helen-gurley-brown-cosmopolitan-editor-hearst-legacy.html.

Schenkar, Joan. *The Talented Miss Highsmith: The Secret Life and Serious Art of Patricia Highsmith*. New York: St. Martin's Press, 2010. https://books.google.com/books?isbn=1429961015.

Shenoy, Preeti. "Why Cats Are Worshipped in Kedar-Gouri Temple." Preeti's Blog. December 30, 2015. http://blog.preetishenoy.com/2015/12/why-cats-are-worshipped-in-kedar-gouri.html.

Sitwell, Edith. *Taken Care Of: An Autobiography*. London: A&C Black, 2011. https://books.google.com/books?isbn=1448201748.

Soto, Ángel. "Monsi: las manías del cronista de la cabellera revuelta." *Milenio*. April 5, 2017. http://www.milenio.com/cultura/carlos_monsivais-biografia-gatos-estanquillo-aniversario-cantinas-milenio-noticias_0_731327054.html.

"Springdale Business Memorializes Helen Gurley Brown." Talk Business & Politics. January 17, 2013. http://talkbusiness.net/2013/01 springdale-business-memorializes-helen-gurley-brown.

Swerdloff, Alexis. "Ann M. Martin on the Enduring Appeal of the Baby-Sitters Club and Rebooting Another Children's Series." Vulture. September 5, 2016. http://www.vulture.com/2016/09/ann-m-martin-missy-piggle-wiggle.html.

Swick, David. "We Live in the Best of All Times: A Conversation with Alice Walker." *Lion's Roar*. May 1, 2007. https://www.lionsroar.com/we-live-in-the-best-of-all-times-a-conversation-with-alice-walker.

"The Cats." The Ernest Hemingway Home and Museum. Accessed July 14, 2017. http://www.hemingwayhome.com/cats.

The Cat Who Club. February 1998. http://thecatwhoclub.tripod.com/id201.html.

Tuckman, Jo. "Carlos Monsiváis Obituary." *The Guardian*. June 24, 2010. https://www.theguardian.com/books/2010/jun/24/carlos-monsivais-obituary.

TwainQuotes.com. Accessed July 15, 2017. http://www.twainquotes.com/Cats.html, http://www.twainquotes.com/19050409.html, http://www.twainquotes.com/Bambino.html.

Walker, Alice. *Anything We Love Can Be Saved: A Writer's Activism*. Reprint ed. New York: Ballantine Books, 1998.

Weller, Sam. "Marguerite Bradbury: 1922–2003—An Appreciation." raybradbury.com. Accessed July 16, 2017. http://www.raybradbury.com/maggie.html.

Wood, Rocky. *Stephen King: A Literary Companion*. Jefferson, NC: McFarland, 2011. https://books.google.com/books?isbn=0786485469.

CREDITS

Page 13: Andrea Roth Photography

Page 14: Fred W. McDarrah/Getty Images

Page 17: Liam White/Alamy Ltd.

Page 18: Marianne Barcellona/The LIFE Images Collection/Getty Images

Page 21: Courtesy Anuja Chauhan

Page 22: © Berit Ellingsen

Page 25: Cleary Family Archives/Wikimedia Commons

Page 26: Fotoe Images/Photoshot

Page 29: GDA/AP Images

Page 30: © Linda Lee Bukowski

Page 33: © Amistad Research Center

Page 34: Imagno/Getty Images

Page 37: Mark Gerson/Bridgeman Images

Page 38: Mark Gerson/Bridgeman Images

Page 41: Sasha/Getty Images

Page 42: J.L. Castel / Archives & Special Collections, Vassar College Library. Ref.#3.454

Page 45: Earl Theisen/Ernest Hemingway Collection/John F. Kennedy Presidential Library and Museum, Boston

Page 46: Peter Hoffman/Redux

Page 49: Associated Press Photo

Page 50: Folkver Per/POLFOTO

Page 53: Bettmann/Getty Images

Page 54: © Lynn Goldsmith

Page 57: Linh Hassel/Age Fotostock/Alamy

Page 58: Akira Ishii/Courtesy Osaragi Jirō Memorial Museum

Page 61: Ferdinando Scianna/Magnum Photos

Page 62: Bettmann/Getty Images

Page 65: Enrique Planas/El Comercio/Associated Press Images

Page 66: © Sridala Swami

Page 69: Nancy Pierce/The LIFE Images Collection/Getty Images

Page 70: © Bettina Strauss

Page 73: © Theo Cote

Page 74: Kenan Research Center at the Atlanta History Center

Page 77: Underwood & Underwood/*New York Times*/Courtesy Wikimedia Commons

Page 78: Carolyn Cole/*Los Angeles Times*

Page 81: © KyleCassidy.com

Page 82: Horst Tappe Foundation/Granger, NYC

Page 85: © Sarita Prasad

Page 86: © Jill Williams

Page 89: © John Engstead/MPTV Images. Image: Raymond Chandler Papers (Collection 638). UCLA Library Special Collections. Charles E. Young Research Library, UCLA

Page 90: © @nickoken

Page 93: AF Archive/Alamy Ltd.

Page 94: © Estate of Aurelia S. Plath/Mortimer Rare Book Room at Smith College

Page 97 and cover: Steve Schapiro/Corbis/Getty Images

Page 98: © Patti Perret

Page 101: Mondadori Portfolio/Bridgeman Images

ACKNOWLEDGMENTS

My sincere gratitude to everyone at Chronicle Books, especially Bridget Watson Payne and Natalie Butterfield. A special thank you to Julien Tomasello, Lynda Crawford, and Kristen Hewitt for their assistance. Cacy Forgenie and Missy, AJ and Tally, Genji, and Aubrey are fondly remembered by many. Thank you to my family and our dear pets; and to Mac, for all his love and support.